MEXICAN AMERICAN

BASEBALL IN

VENTURA COUNTY

Béisboleros in My Day

Stuffed old raggedy gloves and wooden two-by-fours, we played in the barrios and on patches of dirt. This was top of the line gear, for béisbol under the warmth of the sun.
We learned to pitch and catch with calloused hands, with the same fervor that we picked and packed. Not all fields were the same, but we knew how to reap, the fruit of our labor under the blistering heat.

We were proud to be Aztecas, Merchants and Merchanettes.
We went from being Lemon Pickers to Aces and All-Stars of the game.
See, there was a magic when we played this game. It was in our blood like the mixture of sal y limón. It cured all our sorrows and we smiled as we played. Era un jarabe de pobres, one we all shared.

We played ball to the sounds of corridos and the laughter of people. Y era La Voz de la Colonia, a beautiful echo, filling the bleachers. Our friendly rivalries brought together the crowds, who all came to see America's Grand Ol' Game, played by a bunch of braceros and fieldworkers.
And the ladies that played! They seemed soldaderas adorning the diamonds.
Dirt on their cheeks, knees scraped from sliding, "Amorcito Corazón" they had my heart singing.

We kneeled and prayed, asking for a jonron before we stepped to the plate, we summoned all the saints and carried rosaries near our chest. "Gracias Virgencita!" while the crowd went wild!
Even Carlos Luís Hall would have been proud.
The echoes and smiles are vivid, but this game has just begun. We've cleared the fields and pitched the first inning. Our hands and feet are restless as they recall, what it was like to play, béisbol, back in my day.

—Juan J. Canchola-Ventura
Historian and DREAMer student

Front Cover: Agnes Trejo was a member of the 1947 Oxnard F&O Cleaners softball team. The squad included girls of diverse cultural backgrounds. Trejo's tremendous athletic abilities as a pitcher and success as a businesswoman stemmed from the strong support of her parents, husband, and family. (Courtesy of Irene Castellanos.)

Cover Background: The Aztecas were one of the most powerful teams in Southern California during the 1930s. The team was from Santa Paula, and they played on a ball field located at Twelfth and Santa Paula Streets in the barrio known as La Calle Doce on the east side of town. The field was known as Azteca Field. (Courtesy of the Museum of Ventura County.)

Back Cover: Based on a medieval shepherd's play, "La Pastorela" was presented every year on an outdoor stage on Main Street in the barrio in Fillmore. In 1916, baseball player Dolores Sánchez (fifth from left) played the angel, and umpire Manuel Rivas (far left) played one of the devils. (Courtesy of the Sánchez family.)

MEXICAN AMERICAN BASEBALL IN VENTURA COUNTY

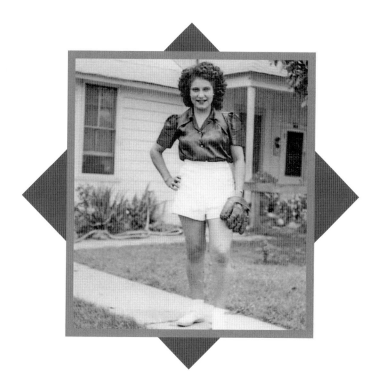

Richard A. Santillán, José M. Alamillo, Anna Bermúdez,
Juan J. Canchola-Ventura, and Al Ramos
Foreword by Jessica Mendoza

ARCADIA
PUBLISHING

Published by Arcadia Publishing
Charleston, South Carolina

Printed in the United States of America

Library of Congress Control Number: 2016940259

For all general information, please contact Arcadia Publishing:
Telephone 843-853-2070
Fax 843-853-0044
E-mail sales@arcadiapublishing.com
For customer service and orders:
Toll-Free 1-888-313-2665

Visit us on the Internet at www.arcadiapublishing.com

To my wife, Teresa, who has been my coach, manager, teammate,
and fan of my work on Mexican American baseball and softball.
—Richard

To my father, José Alamillo, and grandfathers,
J. Encarnación Alamillo and Antonio Herrera Alamillo.
—José

To my family: Mario, Robert, Andrea, and Alicia,
and the next generation of players: Justin, Jack, and Jane.
—Anna

Para mis padres, José Luís y Margarita, and my brother Fernando.
—Juan

To all my sports coaches, who gave of themselves and set an example for me to follow in my 30-year
coaching career, and to my wife, Betty, for her longtime and incredible support of my work.
—Al

CONTENTS

FOREWORD

As long as I can remember, I have had a passion for many things, especially family and sports. Since birth, baseball has been a significant part of my life. Growing up with my father, Gil Mendoza, meant spending hours on baseball fields when he was the head coach at Moorpark College. I felt a great comfort with my dad and sensed early on his deep passion for the game. His love of the game was closely entwined with his Mexican heritage and upbringing. Baseball was the best form of communication between an American-born son and his Mexican born father, a sports bond that crossed cultures, languages, generations, and countries.

Mexican American Baseball in Ventura County reveals how baseball and softball brought families and communities together, regardless of cultural differences. The rich history of community support of baseball and softball is culturally, racially, and gender inclusive. I experienced being the only girl on an all-boys team. I always felt that I belonged, and even when I switched to softball, there was tremendous support from neighborhoods. This amazing encouragement gave me the confidence to challenge all obstacles. This unrelenting persistence that I learned on the field has now taken me to a new career with Major League Baseball as a sports analyst with ESPN.

Ventura County is my home, and it will always be my source of pride. My hope is that young girls and boys will learn, like I did, how important baseball and softball are in their lives because they are important tools to bond, communicate, and influence across all cultures and genders.

—Jessica Mendoza

Jessica Mendoza is an Olympic gold and silver medalist, four-time first-team All-American, and USA Softball Athlete of the Year and is currently a baseball analyst for ESPN's coverage of Major League Baseball.

ACKNOWLEDGMENTS

The foundation of this project to publicize the rich history of Mexican American baseball and softball in Ventura County is the remarkable work of the Latino Baseball History Project at California State University, San Bernardino (CSUSB). Others who supported this effort include the following individuals and staff at CSUSB's John M. Pfau Library: Dean Cesar Caballero and Sue Caballero, Jill Vassilakos-Long (head of archives and special collections), Iwona Contreras, Ericka Saucedo, Amina Romero, Carrie Lowe, Manny Veron, Brandy Montoya, Hayley Parke, John Baumann, and Stacy Magtedanz.

The authors are indebted to the players and families who provided the treasures of photographs and extraordinary oral histories. These dedicated individuals and groups include Ernestina Navarro Hosaki, Irene Castellanos and family, Mary Ramírez, Pricilla Delgado, Ryle Lynch-Cole, Patricia Havens and the Simi Valley Historical Society and Museum, Sandra Davis Gunderson, Joe Jáuregui, Henry Osuna, Helen Brandt, Fr. Lucio Villalobos, Dolores Sánchez, Anna Bermúdez, José M. Alamillo, Rancho de Guadalupe Historical Society, Guadalupe Arts and Education Center, Guadalupe Sports Hall of Fame, the Almaguer family, Eddie Navarro, Frank Navarro, Sal Gómez, Pete Miranda, Mark Silva, Arnoldo De León, José and Rosa Alamillo, Michael Alamillo, Basilio Alamillo, Frank Arguelles, Pilar Pacheco, Daniel Molina, Lamberto M. García, David García, Tara Yosso, José Antonio Romero, Maria Salas, Ana Castro, Judith Dunklin, Rubén and Kathi Oliva, Frank Barajas, Jorge García, Luís Moreno, Ernie Carrasco, Joe Chávez, Jessica Mendoza, Karen Mendoza, Rhiannon Potkey, Nancy Godoy, Monica Pereira, Gloria Cuadraz, Belén Soto Moreno, Samuel Camacho, Mary Guevara, Rodolfo Fragoso Oliva, Daniel Molina, Maria Collier, John Chávez, Rey León, Marty Valdez Nard, David Vargas, Ricardo Reyes, Joe Romero, Bob Recendez, Al De La Rosa, Vic Gomboa, Ray Lara, Carlos Salazar, Bill Contreras, Eddie Chapa, Christopher Docter, Richard Arroyo, Victoria C. Norton, Margaret Valdez Leon, Jack Arenas, Tony Millan Jr., Save Our Heritage Organisation (SOHO), Ruben Saucéda, Irma Ávila, Buddy Salinas, and Teresa M. Santillán.

The authors are also extremely grateful for the following individuals who wrote additional chapters for this publication: David Contreras Jr. for the Merced Region, Maria García for San Diego, and Raymond Serra Jr. and Alicia Serra Stevens for Santa Monica. These three chapters represent the first comprehensive studies to date regarding the history of Mexican American baseball and softball within their respective communities. Thank you all for your magnificent research, boundless energy, and precious time. We express our gratitude again to our in-house editor, Elisa Grajeda-Urmston, and the utmost admiration to our technical consultant, Monse Segura. Finally, we offer our wholehearted respect to Arcadia Publishing and to our remarkable mentor and coach, Jeff Ruetsche, and editor Jim Kempert.

INTRODUCTION

Sandwiched between the urban metropolis of Los Angeles and the quaint coastal city of Santa Barbara, Ventura County stretches before us: 40 miles of sandy beaches surrounded by lush green fields and shaded orchards backed by pristine mountain vistas. The county's major cities include Ventura, Oxnard, Santa Paula, Fillmore, and Camarillo in the north and Thousand Oaks, Moorpark, and Simi Valley at the south end.

Chumash Indians and Californios were displaced from their land by European American settlers who farmed a variety of crops, from grain, lima beans, apricots, walnuts, and sugar beets to citrus fruit. With advances in transportation and irrigation, a demand for fruit and vegetables increased, which led to recruiting foreign workers from China, Japan, the Philippines, and Mexico. Sugar beet and citrus companies employed a racially and ethnically diverse workforce that lived in segregated company housing and attended schools year-round, allowing them to pursue recreational activities.

As Mexican immigrants journeyed to the United States seeking economic security for their families, they brought a passion for baseball with them. If they could not play on school fields, they created their own sandlot diamonds near citrus packinghouses and labor camps. In every Ventura County camp, *colonia*, or barrio, baseball was the most popular sport, especially among young males who showed off their athletic skills on the diamond and also expressed their cultural and masculine pride. The Santa Paula Aztecas and Oxnard Aces were two powerhouse Mexican American teams that developed a rivalry during the 1930s but came together in 1941 to raise funds for evicted families during a long citrus strike. As Mexican *braceros* replaced striking workers, they created a local team to play baseball on Sundays. Braceros played baseball to reclaim their pride and dignity, and also for a counterpoint to the harsh realities of agricultural work. During World War II, Mexican American women entered the workplace and the clubhouses of baseball and softball teams. They joined the Oxnard Merchanettes, Simi Valley Sluggerettes, and Santa Paula Señoritas, among others. These women were pioneers in breaking racial and gender barriers and were the forerunners of Title IX, a landmark federal law to advance gender equity in education and sports.

VENTURA COUNTY

The idyllic view of California as the land of opportunity or the "land of milk and honey" was in the mind of many immigrants to Ventura County. Many Mexicans were fleeing the revolution and heard through family and friends about opportunities in agriculture in this area with its temperate climate and lovely little towns. The grim reality of segregation and less than ideal living conditions hit soon after arrival. For example, the shanty towns that popped up along the banks of Pole Creek outside the town of Fillmore were where many had their first introduction to life in this county. Cardboard and tin shanties were a harsh welcome for those seeking a better existence. Nevertheless, the Mexican communities survived and moved into the barrios, where life was hard but the opportunities to participate in religious and fraternal organizations along with leisure-time activities such as baseball made things palatable.

Ethnic exclusivity in daily life, including religious services, the work environment, and even in baseball were all part of small-town life in Ventura County. Local Mexican baseball teams served to overcome some of those obstacles. Teams like the Aztecas in Santa Paula and the Merchants in Fillmore scouted players who had ability and welcomed Anglo players on their teams, and in a reverse form, served to break down color barriers in a sport long known for exclusion. Teams also played to raise money for community causes such as the Citrus Strike of 1941, when entire families lost salaries and needed support.

Whatever the reason, baseball teams served as a source of pride and solidarity in the communities of Ventura County.

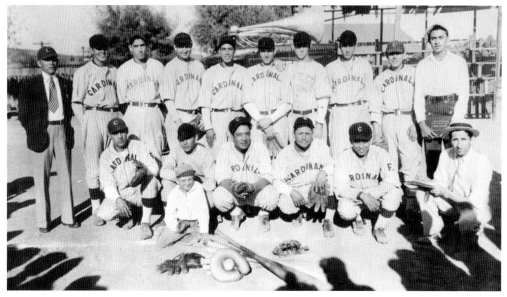

The town of Fillmore had many baseball teams. Although its population was small, baseball was big in this town, whose principal industry was agriculture. From left to right in this 1932 photograph are (first row) Román Pedroza, Tony Guerrero, Ramón Vargas, Dolores Sánchez, Tony Rivas, and unidentified; (second row) umpire Manuel Rivas, Joe Sandoval, Frank Morales, unidentified, Jack Sauceda, Dolores "Babe" Sauceda, and four unidentified. The batboy is unidentified. Hand-built bleachers are visible in the background. (Courtesy of Rubén Sauceda.)

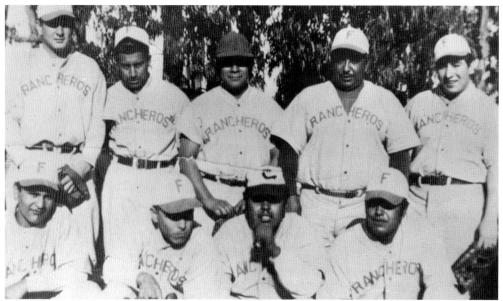

This photograph of the 1930s Rancheros ball team has very little information associated with it. First thought to be from Rancho Sespe, it is highly likely that this was a farmworker team from the town of Fillmore, as the letter "F" on the front of the ball caps would indicate. (Courtesy of Rubén Sauceda.)

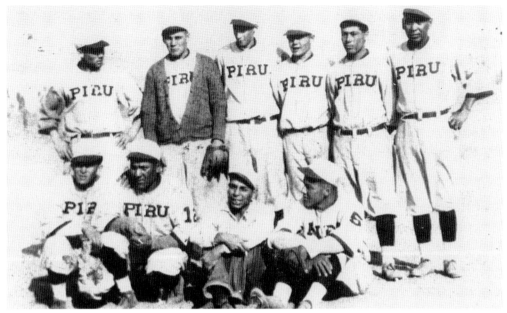

The area around the town of Piru was originally inhabited by the Tataviam Indians. The name "Piru" comes from the Tataviam word for the tule reeds that grow along Piru Creek that were used in making baskets. Founded by David C. Cook in 1887, Piru is the smallest town in Ventura County. However, the Piru Merchants were a well-respected baseball team. These two photographs show the team in different eras. Above are unidentified Piru Merchants around 1930. Below are the Piru Merchants in 1945. From left to right are (first row) Ed Martínez, unidentified, Joe Read, "Sleepy" Martínez, unidentified, Manuel Ortiz, and Elmer Ellis; (second row) Frank Ortiz, unidentified, Fred Real, Chavie Martínez, Jim Ruiz, Dolores "Babe" Sauceda, and two unidentified. (Both, courtesy of Rubén Sauceda.)

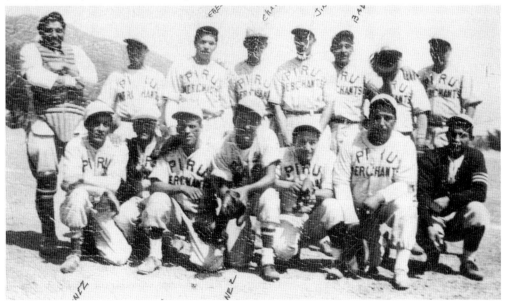

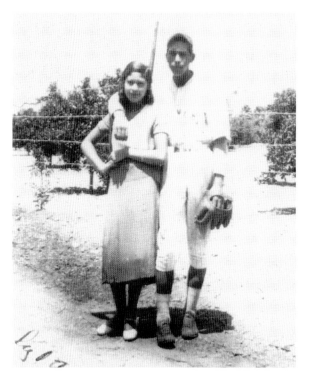

Jack and Josie Sauceda are pictured in 1932. Joaquin "Jack" Sauceda was truly a player extraordinaire. He and his brother Dolores were forces to be reckoned with on the ball field. It was rumored that Fillmore and Piru were considered hotbeds of talent by major-league scouts. Jack was recruited by the Chicago White Sox and went to play for their farm team in Canada. As was the case with many young Mexican American players, the distance from Ventura County and the cultural differences proved too much, and he returned home. (Courtesy of Rubén Sauceda.)

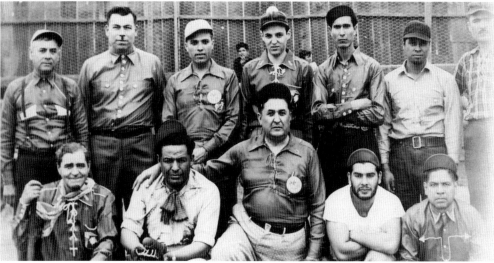

The 1930s ethnically exclusive Santa Paula Merchants team was not open to players of Mexican descent. Determined to take a stand against segregation, Mexican merchants in Santa Paula decided to form their own club whose only criteria for joining was that one had to be an actual merchant. Uniforms were not mandatory, and age and playing ability were not important, but taking a stand against segregated teams was heroic. From left to right are (first row) Manuel Torres, Juan Salas, Arturo Castillo, Richard Mena, and José Ángel Díaz; (second row) Chon Vela, Gil Castañeda, Manuel Victoria, unidentified, Nick Sibrian, Polo Coronado, and unidentified. (Courtesy of the Salas family.)

Of all the teams in Ventura County, none was more feared or more powerful than the Santa Paula Aztecas. The original team name was the Zaragosans. At the start of the 1935 semipro season, Joseph "Gould" Taylor was the starting pitcher for the Santa Paula Merchants, an Anglo team that played at Merchants Field. The Aztecas would change that in short order. On April 22, the Santa Paula *Chronicle* (right) reported that Taylor pitched his first game for the Aztecas and held the opposition scoreless until the sixth inning. The Aztecas were comprised of all Mexican players except for Taylor and Pete Hughes. It is unclear what prompted two white players to switch to a Mexican American team playing against other Mexican league teams in barrio parks. In 1935, that was a bold decision. Most likely, Taylor and Hughes were seeking out the best team and a higher level of competition. This move by two white players forced the all-white Santa Paula Merchants to integrate and bring in an African American pitcher from Los Angeles. (Courtesy of the Joseph "Gould" Taylor family.)

AZTECAS MEET CONQUERORS OF MERCHANTS

Local Nine To Combat Pedigree Dog Food Outfit Here Sunday; Gould Taylor Slated To Pitch

Seeking to avenge for Santa Paula the defeat handed the Merchants last week, the local Aztecas will meet the strong Pedigree Dog Food nine of Los Angeles on Association field Sunday.

While the Aztecas were trimming the Carus Rub On squad last Sunday, the Merchants were taking a shellacking at the hands of the Dog Food outfit at Merchants field. The Angelenos broke the Merchants' five-game winning streak.

The Aztecas are playing better ball than ever and with Gould Taylor chucking for them, loom as one of the most powerful semipro nines in the southland.

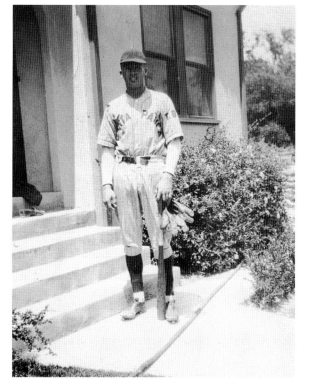

Shown here is Joseph "Gould" Taylor in his Santa Paula Merchants uniform. After joining the Aztecas, Taylor became part of the pitching rotation along with Louis Peralta and Mike Pineda. Taylor had been a stand-out player at Santa Paula High School, captain of the baseball team at Ventura Junior College, and had played Class AA ball for the 1933 Mission Reds in San Francisco. He was a lifelong resident of Ventura County and continued playing baseball into his later years on senior teams as well as coaching youth baseball. He died in Camarillo in 1989 at the age of 80. (Courtesy of the Joseph "Gould" Taylor family.)

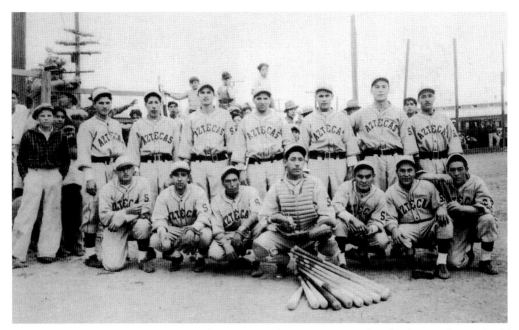

The Santa Paula Aztecas started with players who worked for Teague-McKevett Citrus Association. Players were constantly changing and came from as far away as Santa Barbara to the north and Los Angeles to the south. Everybody wanted to play for the Aztecas. They played on a ball field called El Corralon in the Mexican section of Santa Paula, just west of the Teague-McKevett labor camp. Some of the players in this team photo are Raul and Ralph Maestas, Joe Miranda, Minnie Cobos, and Pete Hughes. In 1933, the Aztecas were one of two teams made up of players who worked for Teague-McKevett in Santa Paula. The association camp was located along the Santa Paula Creek on the eastern side of town in the barrio. (Courtesy of the Museum of Ventura County.)

Newspapers often reported on Mexican American teams. The coverage by these same papers of other aspects of Mexican life in the barrio was almost non-existent except when reporting on crimes, strikes, or cultural events and celebrations. The reporting of games, however, sold newspapers. Besides stories about the games, box scores were included so people could follow their favorite players. And it wasn't just the Santa Paula Aztecas that received attention. Other teams received their fair share of media coverage. This was especially true when teams from the San Fernando Valley and the Santa Maria Valley visited Ventura County. (Courtesy of the Museum of Ventura County.)

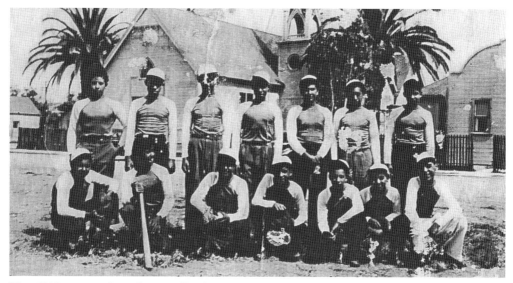

This 1930s team is from the Tortilla Flats neighborhood of Ventura. Considered by many the first neighborhood of Ventura, Tortilla Flats was located along the Ventura River. It was a working-class community of different cultures, from Chumash to Mexican to Asian to those fleeing the Dust Bowl. In an area where community meant more than a shared street address, it was not uncommon to see young ball players playing on the streets, on dirt lots, or at Babe Ruth Field at Seaside Park. (Courtesy of the Museum of Ventura County Research Library.)

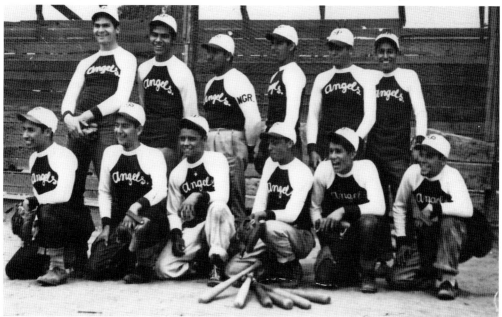

The 1939 Santa Paula Angels consisted of, from left to right, (first row) Benji González, Phillip Villarreal, Tony Vásquez, James Flores, Hank Osuna, and Memo Gonzáles; (second row) Jess Corral, ? Castro, unidentified, Mayo González, ? Gonzáles, and Smiley Carrillo. (Courtesy of the Museum of Ventura County Research Library.)

When Tony Vásquez Sr. of Santa Paula was 20, he had a promising baseball career ahead of him. He overcame the severe asthma he had as a child, and his work in the lemon orchards allowed him enough time to hone his skills on the ball field. All that changed in the fall of 1942, when he received his draft notice. He achieved the rank of staff sergeant with the 119th Infantry, narrowly escaped a prisoner of war camp, and eventually headed back to the United States. Injuries sustained in that escape shattered all hopes of becoming a professional athlete. Vásquez turned his experience into something positive by volunteering as an umpire for Ventura's first Little League program in 1955 and continuing to umpire when the Santa Paula program started a year later. It was a role he proudly held for 50 years. (Courtesy of the Vásquez family.)

The Oxnard Aces, founded by Quito Valles, played on the ball field behind Haydock School. The Aces helped build community in the segregated landscape that was Southern California in the 1930s. There were many industry-sponsored teams in Southern California, and some were already becoming independent entities. Even so, the teams still depended on local businesses for support. While many of the very modest Mexican businesses could not offer financial support, the local Jewish businesses, such as Lehmann Brothers Department Store, stepped up. They paid for uniforms and sometimes balls and bats as well. Shown here is a very young Richard Valles (left) in his Aces uniform with an unidentified boy. Below are the 1933 Oxnard Aces. (Both, courtesy of the Valles family.)

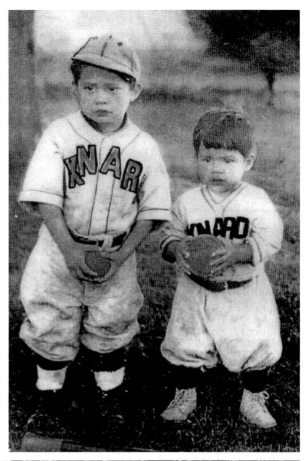

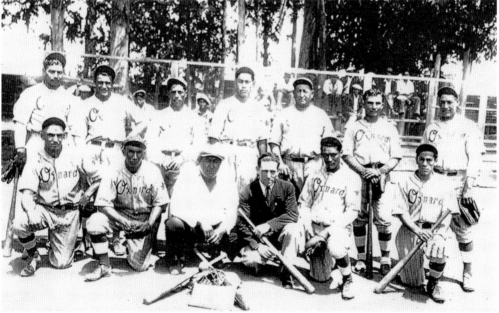

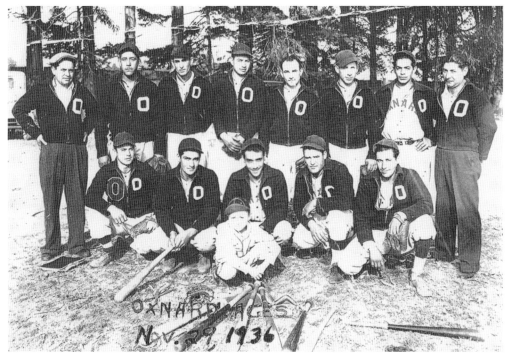

The Aces brought the city of Oxnard much notoriety as they competed against teams from Ventura County and all over Southern California as part of La Asociación Mexicana de Béisbol (Southern California Mexican Baseball League). Pictured above are the 1936 Oxnard Aces. Below is the 1937 team. (Both, courtesy of the Valles family.)

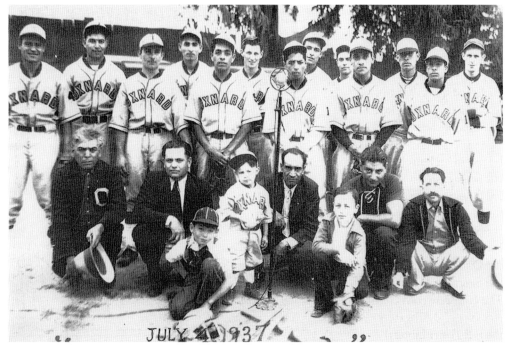

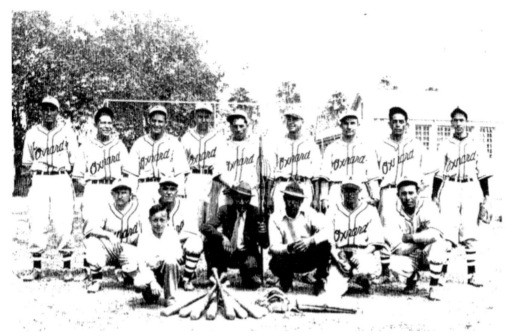

On February 25, 1941, citrus workers went on strike in Ventura County for higher wages, better working conditions, and union recognition. Growers refused to negotiate, and the strike dragged on for six months. The only place where workers could meet was at the ball parks. The Oxnard Aces and the Santa Paula Aztecas played exhibition games in Ventura County to raise funds for strikers and their families. Shown above are the 1939 Oxnard Aces. (Courtesy of the Valles family.)

Baseball was a frequent topic on the front page of *La Voz de la Colonia*. This Spanish-language newspaper was published from 1926 to 1932 in Santa Paula and circulated throughout the central coast. The paper's founder was Oxnard businessman Jesús Jiménez, but he later sold it to Santa Paula newspapermen Manuel Reyes and B. De Hoyos. In this cartoon, "baseboleros" fans at Haydock Park are betting on the Oxnard Aces defeating the Santa Paula Merchants. The fans were correct: the Aces won 5-3 (Courtesy of the E.P. Foster Library)

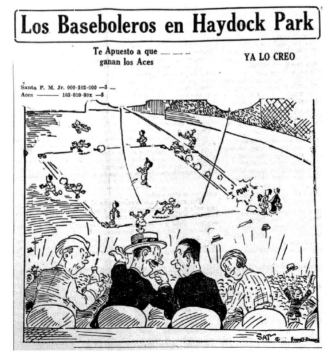

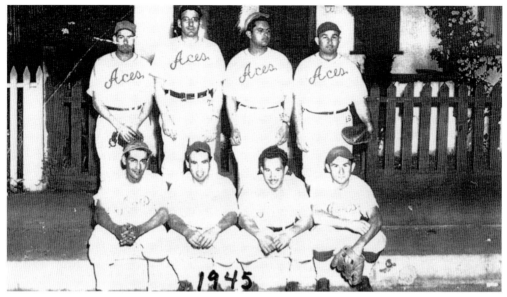

The 1945 Aces were considered a Mexican team but not exclusively so. Most players were of Mexican descent, but the team's star pitchers during the 1946 season were Bobby Wiltfong and Joe Shinkle. As with many of the Mexican American semipro teams, the Aces competed against many semiprofessional black teams as well, such as the Colored Athletics of Los Angeles and the Detroit Colored Giants. (Courtesy of the Valles family.)

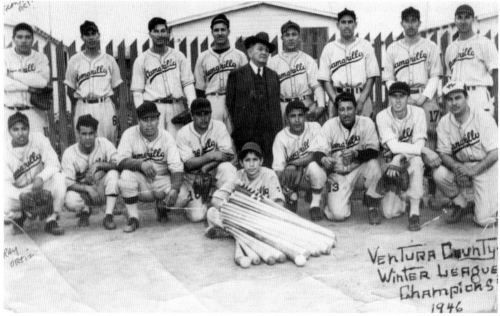

Pictured are the Ventura County Winter League champions of 1946. Don Adolfo Camarillo (black suit) hand-picked his Camarillo team from the best players around the county for the annual Winter League championship. Jake Sauceda (second row, second from left) and Frank Morales (second row, third from right) of Fillmore played on the 1946 team. (Courtesy of Rubén Sauceda.)

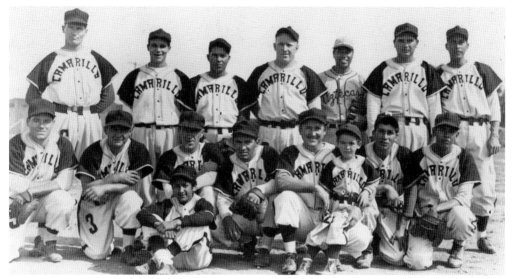

The city of Camarillo is named for Adolfo and Juan Camarillo, who both sought to preserve the city's heritage after the arrival of Anglo settlers. Adolfo Camarillo eventually employed 700 workers growing mainly lima beans, walnuts, and citrus on his ranch. Don Adolfo's love for baseball was evident as he supported many teams during his lifetime. Shown here is one of the Camarillo winter league teams, made up of the best players in the region. Note the player in the Azteca uniform. (Courtesy of Rubén Sauceda.)

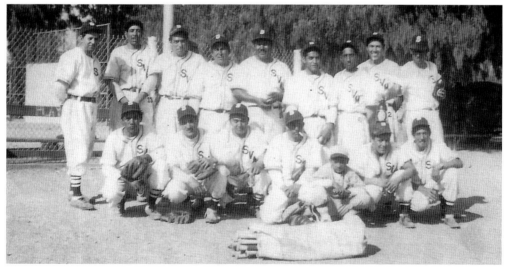

Currently, Mexican Americans make up 16 percent of the population of Simi Valley. In 1950, that number was much lower. That did not deter local Mexican Americans from playing ball. Shown here are members of the Simi Valley Merchants ball club. From left to right are (first row) Julio Hernández, Ángel López, Leonard Anguiano, Joe Anguiano, batboy Armand Patino Jr., Cipriano Alba, and manager Armand Patino Sr.; (second row) Jimmy Barba Sr., Robert Saldino Sr., Benny Tepezano, Jess Arenas, Manuel Sepúlveda, Raúl Hernández, Charlie Silva, Johnny Delgado, and Frank Delgado. (Courtesy of the Simi Valley Historical Society and Museum.)

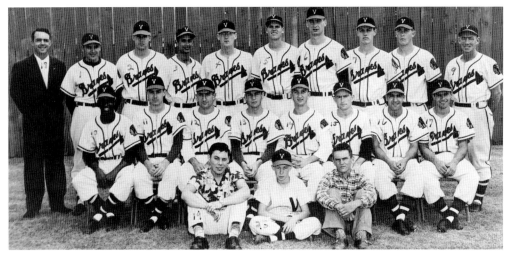

As the years passed, teams became more ethnically diverse. The minor-league Ventura County Braves played at Babe Ruth Field in Ventura in 1950 and 1951. From left to right are (first row) Lynn Stone (business manager), Johnny Solari (clubhouse boy), and Claude Brown (clubhouse boy); (second row) Pablo Bernard (shortstop), Del Smith (pitcher), Bob Andrews (pitcher), Bob Roselli (catcher), Don Mirandetti (third base), Lee Kast (outfielder), Al Luciano (fielder), and Lucky Vital (outfielder); (third row) unidentified, José Pérez (catcher, outfielder), George Owen (outfielder), Alberto Osario (pitcher), "Red" Walsh (pitcher), Jack Lutz (pitcher), Bob Garrett (pitcher), Bud Pfeiller (first base), Bill Denney (pitcher), and Gene Lillard (manager). (Courtesy of the Museum of Ventura County Research Library.)

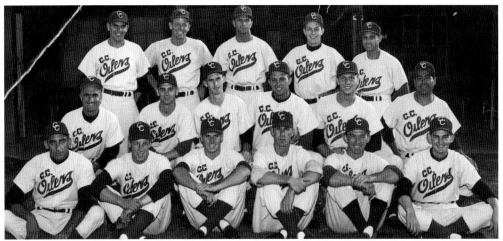

The minor-league Channel Cities Oilers, based in Ventura, played in the California League from 1953 to 1955. They played their home games at Babe Ruth Field. Their name reflects the local oil-drilling industry. Shown in 1954 are, from left to right, (first row) Manny Pérez, Dave Fasholz, Don De Long, George Gruell, Tim Cronin, and Chuck Donley; (second row) Darío Lodigiani (manager), Duane Hudson, Jim Collins, Mike Acker, Jim Leavitt, and Fred Monge; (third row) José Pérez, Dave Melton, Chuck Essegian, Don Domenchelli, and Al Gionfriddo. (Courtesy of the Museum of Ventura County Research Library.)

VENTURA COUNTY

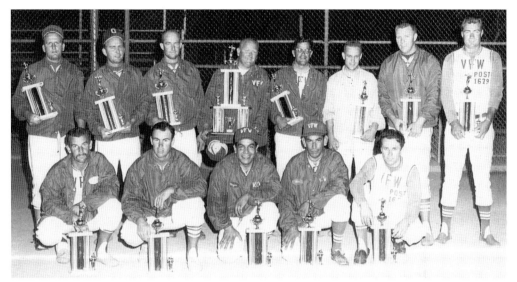

Baseball teams in Ventura County continued in popularity into the 1960s and continued to integrate. This VFW-sponsored team is, from left to right, (first row) Mike McCormick, Danny Jordan, Roger Morales, Mike Morales, and unidentified; (second row) seven unidentified and Al Jensen. (Courtesy of the Museum of Ventura County.)

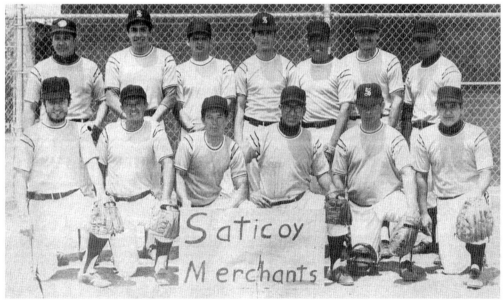

The Saticoy Merchants are pictured in the late 1950s. The Merchants had two of the Alamillo brothers playing for them. The Alamillos' love for the sport spanned generations. Ernie and Joe Alamillo were raised at Limoneira Ranch in Santa Paula until they were evicted during the 1941 Citrus Strike. From left to right are (first row) Joe Magdaleno, Ernie Alamillo, Joe Alamillo, Moses Medina, Mike Morales, and Genaro Centeno; (second row) Johnny Ramírez, Larry Cabral, Bill Tipton, Ben Corona, Sam Morales, Joe Cardoza, and Sam Triana. (Courtesy of the Museum of Ventura County.)

Ernie Carrasco had an outstanding athletic career playing football and baseball at Channel Islands High School in Oxnard. He received a scholarship to play football at the University of Utah, but soon swapped football for baseball, returning to Ventura County. Carrasco is shown here in his playing days at Channel Islands High School in 1979. (Courtesy of Ernie Carrasco.)

In 1982, Ernie Carrasco was signed by the St. Louis Cardinals to play professional baseball. Unfortunately for baseball fans, in 1987, he suffered an injury to his arm while playing for the Cardinals, resulting in his leaving professional baseball. Carrasco continued to give back to his community by coaching baseball and then football at his alma mater, Channel Islands High School. (Courtesy of Ernie Carrasco.)

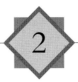

WOMEN PLAYERS OF VENTURA COUNTY

The baseball field provided one of many spaces where young Mexican American girls could flourish as women and members of a bicultural community. Their amazing talent on the diamond redefined social and cultural standards and expectations. By participating in multiethnic softball squads, Mexicanas were able to shatter racial stereotypes and annul submissive or docile labels while providing a momentary pause to social segregation. Without doubt, their athleticism and physical toughness on the field proved girls could step up to any plate and play with the same passion as men. Perhaps more important, however, are the lessons learned from the field that served as an example of progressive transition from girls of a dual cultural identity playing a game, to political involvement, business opportunities, economic independence, and cultural enhancement.

The girls marched onto the diamond like queens in feminine uniforms but played like warriors. They had to play in shorts and tennis shoes; the fact that they had to play in alternate attire speaks loudly of the prevalent gender-specific norms. Parallel to those irrational standards, however, segregation lost any social validity on the field. By displaying their talents and skills, girls were more accepted as individuals and team members; this process increased the trust and mutual dependence necessary to win games. The open field became a space devoted to free female interaction. Inadvertently, this process became increasingly important, especially on multiethnic teams, since it created an alternate paradigm where women shared their similarities and learned to support each other.

The role of cultural context varied and depended on the extent to which traditional values were retained. While it is true that Mexicans embraced traditional values, they also adopted American values as they incorporated themselves into the community. By picking and choosing between two sets of values, young women were able to step out of traditional cultural roles.

This chapter presents an extraordinary collection of photographs and stories of these impressive women in Ventura County, who have served as role models for generations of Mexican American girls who continue to play with the same energy, spirit, and *corazón*.

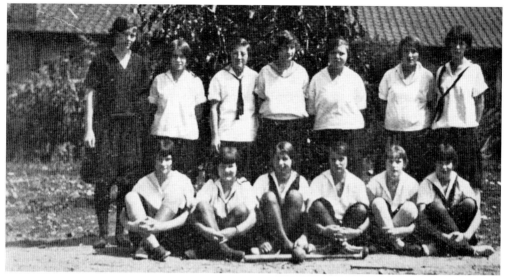

The 1925 Fillmore High School indoor girls' softball team was perhaps the only team to use the word "indoor" in its name. The season for these young women was a short one. The girls' softball schedule was divided into two groups: Fillmore, Santa Paula, and Moorpark composed the first group, while Oxnard, Ventura, and Ojai composed the second. The Fillmore team only faced Santa Paula and Oxnard that season but overwhelmed Santa Paula 19-4. On September 17, 2011, the team was inducted into the Fillmore High School Hall of Fame. (Courtesy of Fillmore High School.)

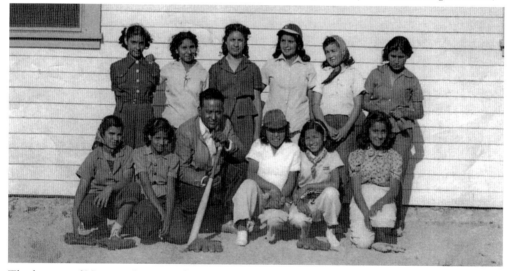

The history of Ventura County is linked to the production of citrus. Rancho Sespe became the largest parcel of land in the county to produce lemons. Owned by Keith Spalding, son of sporting entrepreneur A.G. Spalding, Rancho Sespe formed part of a number of areas that sponsored baseball teams. Alex Davis, pictured here, played on one such team in the 1930s. He also coached a team of local girls, most of them in their teens. Carmen Dolores Ramírez (standing at left) married Davis and then, like many young women, worked in the packinghouses. (Courtesy of Sandra Davis Gunderson.)

WOMEN PLAYERS OF VENTURA COUNTY

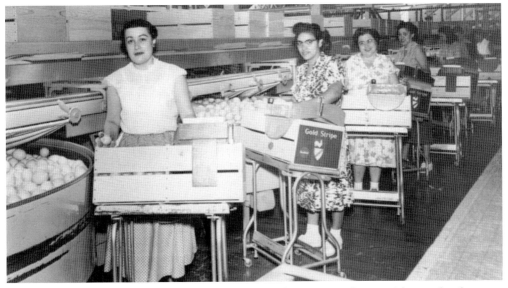

Owned by the Spalding family, Rancho Sespe sought to become a modern model, providing housing, sporting fields, and sponsorship of local events and teams to motivate its labor force to participate in community events and activities while simultaneously increasing quality of production. Women worked in packinghouses, standing for eight hours. In 1953, Carmen Dolores Ramírez (second from left) worked grading Gold Stripe lemons, considered a premium product. Sandra Davis Gunderson, Carmen's daughter, recalls the scent of lemons still vibrant on her mother's clothes after being picked up from her grandmother's house. (Courtesy of Sandra Davis Gunderson.)

In 1947, Agnes Trejo, a resident of Oxnard, became part of the Oxnard F&O Cleaners team, sponsored by a local business of the same name. The team later changed its name to the Patio Girls, sponsored by Lester Hancock, a local entrepreneur. Trejo had to try out when she first decided to play for these teams, though she also played softball for Oxnard High School. She surprised the coach and the other girls in the squad with her pitching ability and was immediately offered a chance to play. No one questioned the decision to include Trejo in the team, and they all welcomed her. (Courtesy of Irene Castellano.)

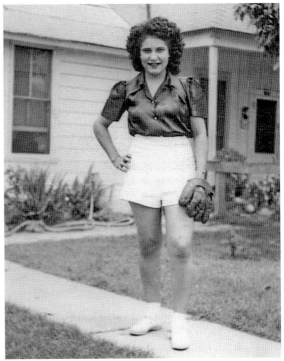

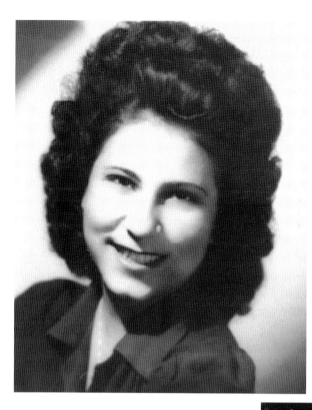

Irene Castellano, Agnes Trejo's daughter, recalls her mom saying that she was afraid to speak Spanish for fear of being ridiculed though she was fluent. Trejo, like many other girls, had to navigate between her two cultures. As a result, she became a woman very much involved in the community. Trejo (pictured) graduated from Oxnard High School and became a local business owner. She became a member of the Fraternal Order of the Eagles 232 and served as president. She also belonged to the Veterans of Foreign Wars Ladies Auxiliary, the Fleet Reserve Association Ladies Auxiliary, and the American Legion Auxiliary. (Courtesy of Irene Castellano.)

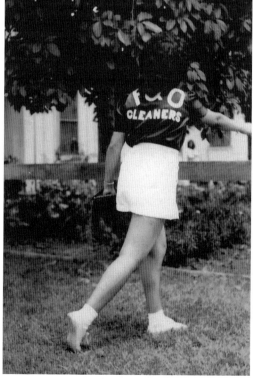

Showcasing her pitching talent for softball in full F&O Cleaners girls' softball uniform in front of her home around 1947, Agnes Trejo led her teammates to many victories around Ventura County. The team, which was later renamed the Patio Girls, played throughout Ventura County, often defeating rival women's teams. The Patio Girls sponsor, Lester Hancock, and their manager, Tom Newman, advertised exciting games in the local newspaper, the *Oxnard Press Courier*. The girls never disappointed, often delivering blowout games in favor of the Oxnard team. (Courtesy of Irene Castellano.)

While the women who played softball delivered great games, it was common to have a small audience mostly composed of the girls' family members. Games and their outcomes were published in the *Oxnard Press Courier*. Here, Agnes Trejo stands at the mound ready to pitch in a friendly game in Oxnard around 1947. (Courtesy of Irene Castellano.)

The Patio Girls from Oxnard played in the community center, located on C Street between Seventh and Eighth Streets. The field was also the location where Oxnard High School was first built, and was the local venue where most baseball games and other community events took place. The iconic Spanish-Moorish architecture of the building can be seen in the background as Agnes Trejo pitches during a 1940s game. (Courtesy of Irene Castellano.)

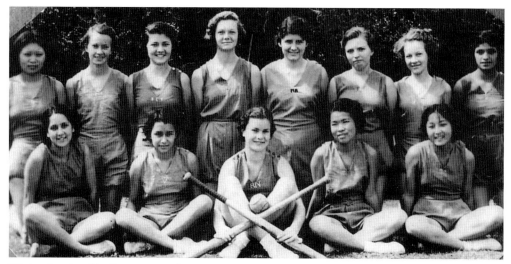

High school softball encouraged young women to participate in extracurricular activities. In Ventura County, the history of high school softball can be traced to the 1920s. Squads reflected the population, as they included different ethnic backgrounds. Here, the 1934 Oxnard High School freshman softball team poses for the yearbook. The freshman squad defeated the senior team that year, putting an end to a three-year championship streak. From left to right are (first row) Jiménez, Martel, Neal (captain), Tokuyama, and Yamada; (second row) Maeyama, Borchard, Warren, Diedrich, Álvarez, Fournier, Callens, and Palomena. (Courtesy of Gregory Ramírez.)

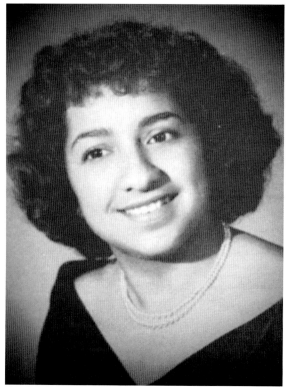

In 1958, Gloria Valencia pitched for the Oxnard Oxiettes. Her oldest sister Lydia Valencia, Gloria García, Vickie Lerma, Ruth Ontiveros, Ruth Rodríguez, Genevieve Valdez, Jennie Valdez, and Rita Zuñiga comprised the team. They competed against teams like the Hobos, Laundairettes, Ray Lasses, Missile Bees, Girl's Athletic Club, and Olympic Gym for the Women's Softball League in Ventura County. With Gloria García at the mound and power hitters Jennie and Rita, they beat the Tatums 15-4. Valencia's phenomenal performance during the season earned her a spot on the all-star team. (Courtesy of Sandra L. Uribe.)

At Oxnard High School, the graduating class of 1959 voted Rita Zuñiga "most athletic." As an active student, she participated in multiple Girls Athletic Association sports and student government and was a member of Las Damas. Las Damas, a service club, organized female students of Mexican descent to coordinate a Cinco de Mayo assembly, attend cultural field trips, and help local communities. They particularly focused on needy children in the Colonia, a Mexican community in Oxnard. As a junior and senior, Rita joined the Oxnard Oxiettes, becoming a top hitter for the team. (Courtesy of Sandra L. Uribe.)

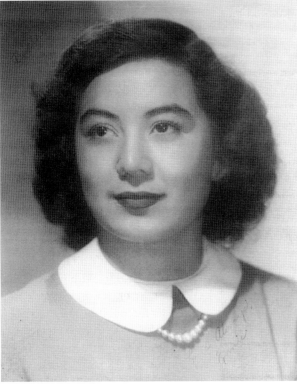

In the early 1950s, the Cotler's Girls changed their name to the Oxnard Merchanettes. The team was sponsored by several local merchants. The Merchanettes were difficult to beat, often leading the county league. Ernestina Navarro Hosaki, a pitcher for both teams, played the game with no fear. She recalls sliding into base in shorts, often scraping her leg, but she did not mind the pain. All she wanted to do was play. (Courtesy of Ernestina Navarro Hosaki.)

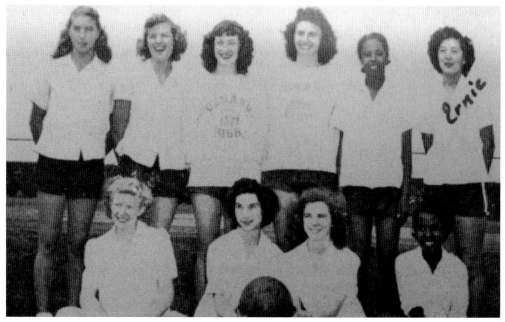

Standing at far right with the 1949 Oxnard High School girls' basketball team, Ernestina Navarro Hosaki always enjoyed sports. Aside from playing baseball for the Merchanettes, she played high school soccer, volleyball, and basketball and was involved in clubs such as the Spanish Club. After high school, she married Butch Hosaki, of Japanese descent, and worked at the Oxnard School District office. Even at the age of 84, she continued to be active, volunteering at the Wilson Senior Center of Oxnard. (Courtesy of Ernestina Navarro Hosaki.)

The late 1940s Dolly Brighams were another Oxnard softball team. The girls were sponsored by the Dolly Brigham dress shop. The squad played against teams from Santa Barbara and Ventura Counties. The team included, from left to right, (first row) J. Kohler, F. Mills, M. Tricker, H. Arosteguy, E. Strobel, and coach E. Weldon; (second row) D. Davidson, J. Kenney, F. Glenn, N. Brumer, I. Martell, and R. Jouregui. (Courtesy of Helen Brandt.)

WOMEN PLAYERS OF VENTURA COUNTY

In Oxnard, other groups incorporated young women of all backgrounds, possibly due to the increase in cultural diversity. Fr. José de Jesús Madera Uribe, pastor of Our Lady of Guadalupe, organized various extracurricular organizations that allowed young women to invest their time in productive ways. One of these groups, the Oxnard Colonnades, became widely known as a drill team that participated in parades locally and outside of the county. Here, the second generation of the Colonnades poses during the 1976 bicentennial celebration in Port Hueneme. (Courtesy of Elizabeth Verduzco.)

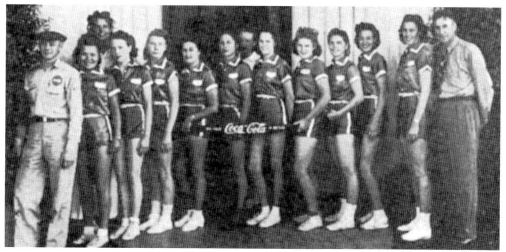

The Coca-Cola bottling companies throughout California sponsored sports. In Ventura, the local bottling company sponsored the Coca-Cola Softball Squad. The games were included in weekly souvenir programs sponsored by the Women's and Men's Sports League of the Santa Barbara Recreation Commission. The 1940 team includes, from left to right, Alvin Smith (assistant manager), R. Young, M. Garreson, D. Boleyard, L. Bolyard, McConhay, W. Bertles, D. Piker, G. Rhoder, P. Swanson, P. Cline, E. Rhoades, R. Dennison, and Paul Miller (manager). (Courtesy of Helen Brandt.)

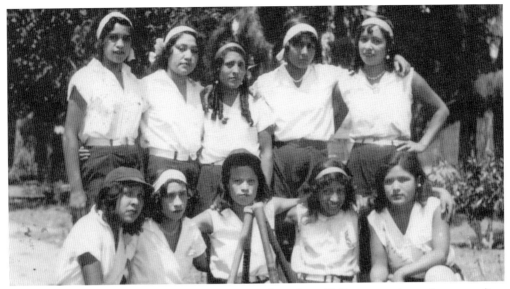

During the 1930s, a group of young Mexicanas from Simi Valley created a unique traveling softball team. The team's proximity to the San Fernando Valley presented the opportunity to play frequently both inside and outside of Ventura County, unlike other teams that mostly played within the county. The team was managed by Lucille Vásquez, also part of the team. This is one of the few teams in Ventura County composed of all Mexicanas and managed by a woman. From left to right are (first row) Juanita Muñoz, Eleanor Padilla, Victoria Soto, Ruby Ferrer, and Lucy Ferrer; (second row) Angelina Padilla, Lucille Vásquez, Jessie Ferrer, Christina Martínez, and Ida Jaramillo. (Courtesy of Everett "Joe" Chávez.)

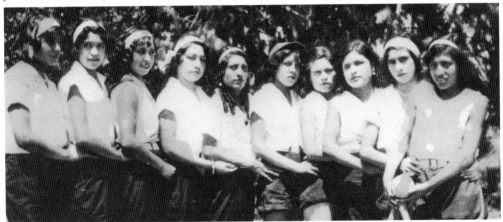

One of the unique features about the girls who played in the 1930s was their uniforms. Typically comprised of shorts or skirts, tennis shoes, and blouses, uniforms were not practical for playing; rather, they were meant to emphasize the girls' femininity. Joe Chávez's mother, Lucy, and aunts Jessie and Ruby recall the girls using accessories and makeup while sporting their uniforms. Uniforms progressively changed for women, using pants and even jeans. From left to right are Christina Martínez, Angelina Padilla, Ida Jaramillo, Lucille Vásquez, Jessie Ferrer, Juanita Muñoz, Victoria Soto, Lucy Ferrer, Eleanor Padilla, and Ruby Ferrer. (Courtesy of Everett "Joe" Chávez.)

Games were commonly played on Sundays after church. Women played before men when games were scheduled on the same day. Here, two teams stand before a game on the Simi Valley Elementary School campus in the 1940s. The campus, considered a community center, hosted games and practices for both genders. The girls on this team—from left to right, Inez Aguilar, Mary Chávez, unidentified, Eleanor Chávez, Lucy Delgado, and four unidentified—stand next to an all-male team with the name faintly written on their jerseys. (Courtesy of the Simi Valley Historical Society and Museum.)

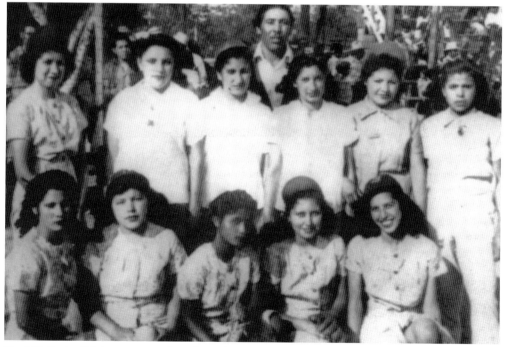

Simi Valley's all-Mexican squads reflect the deep affiliations between family and community. In many cases, the women who participated in sports belonged to families with long standing historical ties or contributed to local organizations in Simi Valley. Among them, the Delgado, Chávez, and Verdugo families are well known in the community. Pictured from left to right in this 1940s all-Mexican softball team are (first row) unidentified, Eleanor Chávez, two unidentified, and Nellie Delgado; (second row) Lucy Delgado, two unidentified, Robert Saldaña (coach), Irene Alba Verdugo, Mary Chávez, and Inez Aguilar. (Courtesy of James V. Verdugo.)

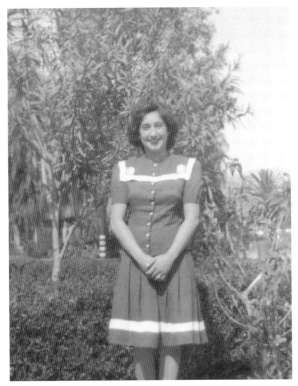

As a young woman in the 1940s, Irene Alba Verdugo played alongside the Delgado and Chávez sisters on a Simi Valley team. Irene, raised in Simi Valley, loved to play ball just like her siblings. After marrying James Verdugo Sr., a talented gymnast, musician, and member of the Air Force, Irene worked as a self-taught dietician in the San Fernando Hospital, where she retired in 1971. Even though she had many interests, her greatest passion by far was taking care of her family. (Courtesy of James V. Verdugo.)

For cities like Simi Valley, located on the outskirts of the county and sparsely populated during the 1940s, activities both inside and outside of the city were important, especially as Simi Valley began to incorporate itself into Ventura County on a larger scale. Representing the community became an important source of pride. Here the Simi Valley Sluggerettes, a mixed team of Anglos and Mexican Americans, proudly pose on a truck to showcase their victory trophy in full uniform with "Vela's Sluggerettes" banners. (Courtesy of the Simi Valley Historical Society and Museum.)

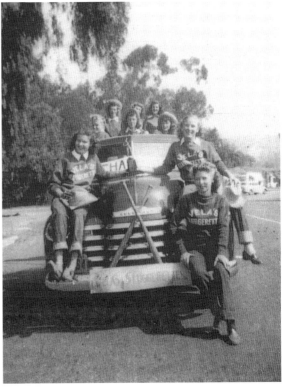

WOMEN PLAYERS OF VENTURA COUNTY

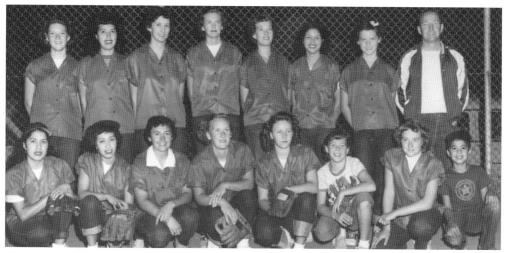

The Simi Valley Sluggerettes were sponsored by Vela Boyer, owner of Vela's Luncheonette. The Sluggerettes were one of several multiethnic girls' teams that played throughout Ventura County during the 1940s. The girls' rugged uniforms were a testament to gender-bending change as they stepped onto the field in jeans instead of the typical shorts. The Delgado sisters, Mary and Nellie, are among those whose family ties to Simi Valley have contributed to the town's Mexican heritage. Pictured around 1947 are, from left to right, (first row) Estela Tepezano, Mary Delgado, three unidentified players, Bonnie Proctor, unidentified, and James Vásquez; (second row) unidentified, Nellie Delgado, two unidentified, Miriam Varble, Barbara Rodríguez, unidentified, and coach Waddy McGuire. (Courtesy of the Simi Valley Historical Society and Museum.)

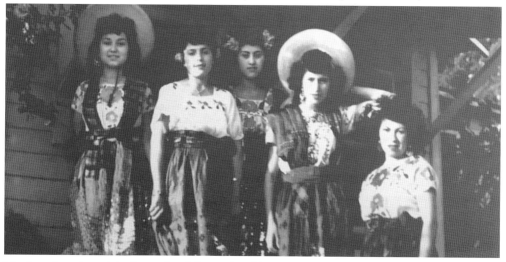

Mexican American girls often utilized their cultural heritage as a way to participate in the community. Girls planned, prepared, and even dressed up in folkloric attire during celebrations such as Mexican Independence Day and Cinco de Mayo to preserve and celebrate their Mexican identity. These celebrations also raised funds for nonprofit organizations. Standing in full *charrita* dress in Simi Valley in the 1940s are, from left to right, Lucy Gómez, Josie Cota, Mary Helen Díaz, Georgia Rodríguez, and Lucy Delgado López. (Courtesy of the Simi Valley Historical Society and Museum.)

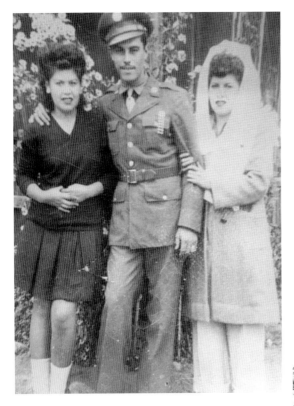

The Delgados are among the most recognizable families in Simi Valley. Mary Ramírez Delgado and Nellie Vásquez Delgado both played for the Sluggerettes. Nellie also volunteered at the Strathearn Historical Park and Museum, and Lucy actively volunteered in Mexican fiestas, while other members of the Delgado family joined the armed forces. Pictured here in the 1940s are Ramona Delgado Banaga (right) next to Nellie's husband, Jimmy Vásquez, and Lucy Delgado (left). Ramona purchased land where the old St. Rose of Lima Church was built, donated the church to the museum, and moved it to the museum grounds. (Courtesy of Pricilla Delgado.)

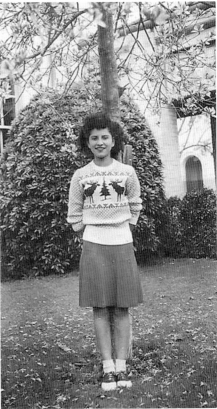

Women also found alternate ways to be active in the 1940s. Celia Leon Díaz did not play sports, but her contributions to her native Santa Paula are seen every day. Celia was a founding member of the downtown mural initiative that decorated the town's vibrant streets, served on the theater committee, and was a board member of the Santa Paula Historical Society, where she organized photographs. She married Tony Díaz, proprietor of the Familia Díaz Restaurant, where her cooking became well-known. She was an example of women creating new paths and redefining the roles of young Mexicanas. Even at the age of 70, she continued to inspire and enjoy life by teaching cooking classes, publishing a cookbook, and graduating from culinary school. A world traveler, she visited dozens of countries before passing away in 2013. (Courtesy of the Díaz family.)

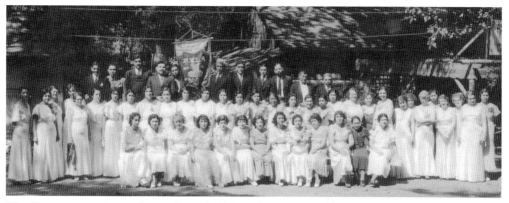

The Campamento Benito Juárez Sociedad Mutualista, pictured here in Steckel Park in the 1930s, is among the mutual aid organizations and auxiliary groups that organized events in the barrios of Santa Paula. The goal of these organizations, created by Mexican immigrants, was to promote solidarity among the community and arriving immigrants while improving the established community. It should be noted that many of the fundraising events, activities, and programs were largely possible thanks to the work and dedication of the women who organized and educated the community. (Courtesy of the Flores family.)

Jessica Mendoza, the daughter of Karen and Gil Mendoza, began playing in the Camarillo Girls Softball Association and earned All-California Interscholastic Federation honors and Female Athlete of the Year at Camarillo High School. At Stanford University, she was a four-time first-team All-American from 1999 to 2002 and was named Stanford Athlete of the Year three times. Mendoza earned two Olympic medals, a gold medal in 2004 in Athens and a silver medal in 2008 in Beijing. In addition to her collegiate and Olympic accomplishments, she also led the national pro fast pitch softball team to victory in 2010, and is a two-time Pan American Games gold medalist. (Courtesy of MiBelle Photography.)

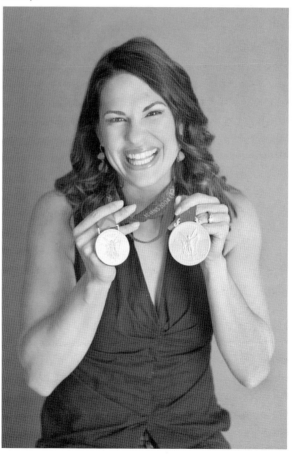

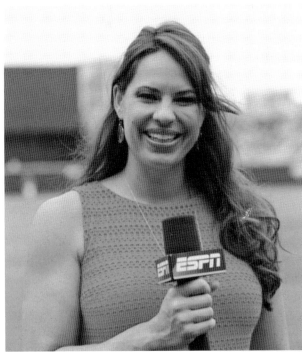

Jessica Mendoza became the first woman to call an ESPN Major League Baseball game as a baseball analyst on August 24, 2015. Mendoza is proud of her Mexican American heritage and was inducted into the International Latin Sports Hall of Fame in 2006. She is a pioneer for women's sports, education, and human rights. Mendoza is the president of Women's Sports Foundation, the athletic ambassador for Team Darfur, and a board member of the National Education Association. (Courtesy of the *Ventura County Star*.)

Agnes Trejo of the Oxnard Patio Girls stands as a reminder of the grace, talent, and courage that women displayed on the field. Every step these young women took forward changed their lives and the lives of everyone around them. No challenge was too great and no accomplishment was too small. Their memory and stories will continue to inspire and encourage young women and serve as an example for generations who grow with the same love and passion for the game these girls had. (Courtesy of Irene Castellanos.)

BRACEROS AND VENTURA COUNTY BASEBALL

Sunday was the only day of rest from the bone-crushing farm work that Mexican braceros did in order to put fruits and vegetables on America's dinner tables. The bracero program began in 1942 as an emergency agreement between the United States and Mexico to resolve a severe labor shortage during World War II, but after the war, agricultural employers were so addicted to cheap labor that they lobbied to extend the program several times until labor unions, churches, and civil rights groups fought to end the program in 1964. Aspiring braceros were herded into soccer and baseball stadiums or other large venues with the hope of receiving a contract. During those 22 years, over 4.6 million contracts were signed by braceros.

During their *dia de descanso*, braceros attended mass, watched Mexican films, went window shopping, or participated in sports such as soccer, volleyball, basketball, and baseball. A majority of braceros originated from northern and western regions of Mexico, where baseball was more popular than other sports. Baseball arrived in Mexico in the 1860s and grew more popular when Jorge Pasquel's Mexican League lured major-leaguers to Mexico with lavish salaries. During World War II, Pasquel used his government contacts to arrange a "baseball trade" that involved two Negro League players in exchange for 80,000 Mexican braceros.

Camp managers promoted baseball by organizing teams, supplying equipment, and clearing out an open field near the camp. Baseball was viewed as a wholesome sport that presumably kept braceros from visiting bars, drinking, and getting in trouble in nearby towns. Braceros organized themselves into baseball teams and played against teams from local high schools, civic groups, and labor camps. When a bracero visited the local town by taxi or bus, he searched for opportunities to play ball in recreation centers or parks. Sometimes Mexican American baseball teams requested permission from camp managers to recruit braceros. Baseball allowed braceros to reunite with old friends, meet new people, and extend their social network outside the camp. This network became crucial after the end of the bracero program to help them find work and bring their families to settle in the United States.

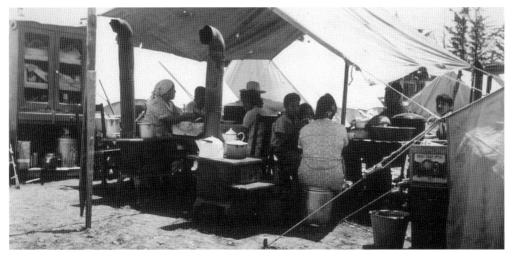

On February 8, 1941, over 6,000 Mexican lemon pickers went on a six-month strike against Ventura County's citrus industry. With help from the Agricultural Citrus Workers Union Local 22342, an affiliate of the American Federation of Labor (AFL), the strikers demanded higher wages, compensation for waiting time due to moisture on trees, and union recognition. Lemon packers, the vast majority of them Mexican women, soon joined the picket lines in front of 13 packinghouses in Saticoy, Santa Paula, Oxnard, and Ventura. The Ventura County Lemon Growers launched a media campaign to discredit the AFL organizers and preferred to lose their crop rather than accept unionized farm labor in the citrus industry. In the fourth month of the strike, Ventura County Lemon Growers still refused to negotiate with the AFL and threatened to evict the strikers from company housing. On May 5, 1941, the Limoneira Company shut off gas and electricity and evicted over 700 families. Evicted families settled in tent camps such as "Teagueville" in Steckel Park (below), Santa Paula, "Kimballville" in Seaside Park, Ventura, and a Farm Security Administration camp in El Rio, near Oxnard. The photograph above shows an evicted family cooking dinner at Teagueville. The camp was named after Charles C. Teague, president of Limoneira Company and Sunkist Growers Inc., who evicted the strikers and imported Anglo Dust Bowl migrants to end the strike. (Both, courtesy of Farmers Home Administration Records, National Archives, San Francisco.)

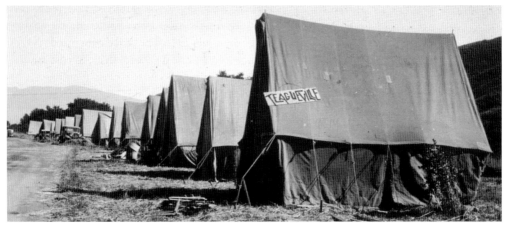

Baseball helped unionization efforts in Ventura County. The largest place where the union could hold its meetings was at the ballpark. The *Oxnard Press Courier* reported on February 10, 1941, that "two union meetings were held, one at the Haydock School ball park and the other at the Azteca ball park in Santa Paula, with between 3,500 and 4,000 picking and packinghouse employees." Since many of the strikers were also baseball players, they used their sporting networks throughout Southern California to solicit financial and moral support. Some of the coaches emerged as labor leaders for the Agricultural Citrus Workers Union by using their managerial skills, scheduling tournaments, fundraising, and using their networks. This April 15, 1941, *La Opinion* article details how two rival teams, the Oxnard Aces and the Santa Paula Aztecas, organized a special exhibition game at White Sox Park in Los Angeles to raise funds for lemon strikers and their families. Baseball games at the tent camps also helped keep up the morale of strikers during the bitter six-month strike. (Courtesy of *La Opinion*.)

ASES DE OXNARD VS. SANTA PAULA EN EL WHITE SOX

Jugarán el domingo, a beneficio de los huelguistas de Ventura

Según nos informa el señor Jesús Sánchez, líder de los pizcadores mexicanos que están en huelga en el condado de Ventura, el próximo domingo se celebrará en el parque White Sox otra función deportiva a beneficio del fondo de ayuda para las familias de los huelguistas.

Estas contiendas beisboleras vienen celebrándose desde hace tres semanas, entrando en acción como atracción estrellas las novenas mexicanas Aztecas de Santa Paula y Ases de Oxnard, ambas formadas en su mayoría por los mismos huelguistas. Hace tres semanas los Aztecas y los Ases sostuvieron su primer encuentro en Santa Paula, a beneficio del fondo de la huelga; el domingo siguiente se enfrentaron nuevamente en el Parte Hayddox de Oxnard, y el domingo pasado unieron sus fuerzas para venir a jugar al White Sox contra los campeones japoneses del equipo Three Star Produce. Los mexicanos ganaron con anotación de 11 a 6 carreras.

Para el próximo domingo, según anuncia el señor Sánchez, las dos novenas favoritas de los aficionados del condado de Ventura, los Ases y los Aztecas, vendrán a Los Angeles para enfrentarse en el diamante del White Sox, a dos de los equipos locales más fuertes que pueda proporcionar la Asociación de Basseball del Sur de California.

Dos juegos serán presentados en el White Sox, con los Ases de Oxnard y los Aztecas de Santa Paula como atracción estrella.

Corrido de
La Huelga de Pizcadores

Señores tengan presente
Lo que les voy a cantar
Pidiendoles mil perdones
No se vayan a enojar.

El día 13 de Febrero
Presente lo tengo yo
Que en el pueblo de Fillmore
La huelga se declaró.

Ese día tan señalado
Nunca se nos va olvidar
Que todos los mexicanos
No fuimos a trabajar.

Y entre nosotros había
Algunos americanos
Que se unieron a nosotros
Y chocabamos las manos.

Cuando ya nos retiramos
Y nos fuimos caminando
Todititos los rancheros
Nomas nos iban mirando.

Y cuando Severo sacó
Del carro los cartelones
Los rancheros se le fueron
Que parecian unos leones.

La guardia se acomodó
Al derredor del empaque
Y todos a una, se oyó
Ahora es cuando no se rajen.

De la oficina en la entrada
De donde salió un ranchero
Insultando a mis paisanos
Y tirandoles dinero.

Los considero paisanos
Como se sentirian
Al mirar a los rancheros
De vengarse tratarian.

Pero todos muy prudentes
Ninguno les respondió
Más uno de este pueblo
Siempre la pata metió.

Les suplico atentamente
Nos cuidemos lo mejor
No se crean lo que cuente
Ese amigo el esquirol.

De esquiroles esta lleno
Por el Condado de Ventura
Y si nosotros ganamos
Para ellos será la amargura.

Pobrecitos esquiroles,
Yo les tengo compasión
No saben otro trabajo,
Nomas que pizcar limón.

En este pueblo hay algunos
Que les tengo compasión
Prefieren pagar la multa
Y no cargar el cartelon.

Les suplico compañeros
Que de ellos no hagan apercio
Voy a hablarles un poquito
Tocante a los del comercio.

El señor José González
Es nuestro verdadero hermano
Pues facilitó con gusto,
De su tienda el subterráneo.

En todo tiempo paisanos
Les pido de corazón
Protejan la Mexicana
Al comprar su provisión.

Y despues de tanto escribir
Me esta saliendo una ampolla
Pues tambien les recomiendo
La tienda de la Victoria.

Y ya para despedirme
Les recomiendo a Severo
Comprenle un galon de seco
Por que es un buen compañero.

Ya con esta me despido
Con mi sombrero en la mano
Estos versos son compuestos
Por un humilde paisano.

Fillmore, California Febrero 22 de 1941

Strike aid committees were formed to solicit food and monetary donations and to mobilize public support via radio and newspaper. One striker composed "Corrido de La Huelga de Pizcadores," which told the story of how growers attempted to break the strikers' unity through intimidation, but with help from the Mexican community and shopkeepers, strikers hoped to achieve victory. However, when growers began importing Dust Bowl migrants as strikebreakers, the union ended the strike in July 1941. The strike convinced Ventura County citrus growers that the best way to block unionization was to replace longtime workers with more "compliant" workers from Mexico. Mexican braceros, imported between 1942 and 1964, were not only used to alleviate the wartime labor shortage, but also to thwart future unionization efforts. It is not a coincidence that the largest farmworker strike occurred in Delano, California, in 1965, a year after the bracero program ended. (Courtesy of Anna Bermúdez.)

CONSEJOS A LOS TRABAJADORES MEXICANOS

que pasan a los Estados Unidos, contratados por la "War Food Administration" (Administración de Alimentos en Tiempo de Guerra).

MEXICO
1944

The Mexican government contributed to the Allied cause in World War II by exporting its workers to the United States to alleviate the labor shortage, especially in agriculture. They were called braceros, which literally means men who worked with their arms, or "strong-armed men." Claiming that the bracero program would help modernize the country as men sent money back to their families or returned with savings to open businesses, the Mexican government approved more than 4.6 million contracts with the US government, which promised to uphold the contracts' obligations and conditions. This 1944 handbook, published and distributed by Mexico's secretary of foreign affairs, advised braceros to obey the laws of the United States and if they encountered problems to consult the nearest Mexican consulate. (Courtesy of the Museum of Ventura County.)

The bracero program was presented as a model labor program that resolved labor shortages and fostered international goodwill. The industry published a magazine called *Agricultural Life* that presented a romanticized version of the bracero program, but the reality was far different. The inaugural issue featured 19-year-old Policarpio Ruiz perched on top of a ladder picking lemons. Ruiz arrived in Oxnard's labor camp from Nayarit, Mexico, with his father to pick lemons, but climbing up and down the ladder all day while carrying a heavy bag forced his father to quit and return home early. Ruiz complained that when orchards were wet and muddy there was a higher risk of falling. Harsh work conditions did not stop lemon growers from hiring more braceros. By 1963, seventy percent of lemons were picked by braceros. (Courtesy of Samuel Camacho.)

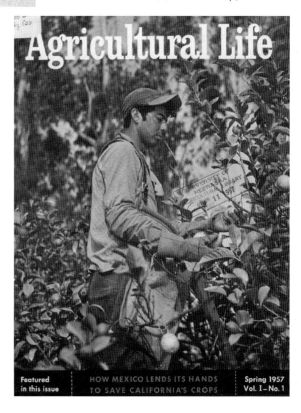

Agricultural Life

Featured in this issue | HOW MEXICO LENDS ITS HANDS TO SAVE CALIFORNIA'S CROPS | Spring 1957 Vol. I – No. 1

VENTURA COUNTY CITRUS GROWERS COMMITTEE
Santa Paula, Calif.

This Certifies that Mexican agricultural worker
HERNANDEZ-Romero, Jose

Contract No. I-2865713 completed

Is contract on 4-17-59 with the
S.P. Cit. & Briggs Lemon

they found his services satisfactory.

By *Victor Behar*

The bracero program made a significant impact on the political economy, migration patterns, and ethnic relations in Ventura County. Of the 4.6 million bracero contracts, 20 percent were issued to Ventura County, more than any other county in the state. The Ventura County Citrus Growers Committee was the primary contractor of braceros in the county, in charge of recruitment, work assignments, transportation, housing, and establishing a flat wage rate. At least 25 bracero camps were located in Piru, Fillmore, Santa Paula, Ventura, Saticoy, Moorpark, Simi Valley, Somis, Camarillo, and Oxnard. (Courtesy of the Bracero Oral History Project, California State University, Channel Islands.)

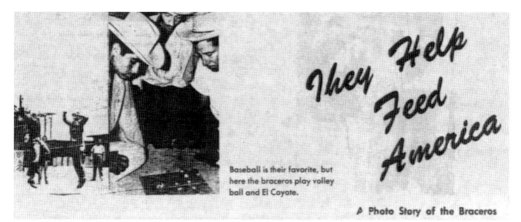

They Help Feed America

Baseball is their favorite, but here the braceros play volley ball and El Coyote.

♪ Photo Story of the Braceros

The American Medical Association published this 1957 *Today's Health* article about braceros in California. The article claimed that they received good medical care and treatment and were allowed to play baseball, volleyball, and a Mexican board game called El Coyote. In actuality, however, braceros sometimes did not receive medical care and were not allowed or were too tired to play sports. (Courtesy of Ernesto Galarza Papers, Stanford University.)

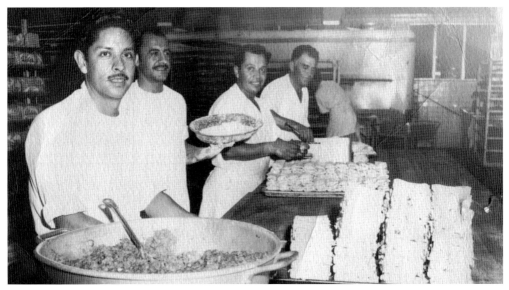

Lamberto M. García was born on June 1, 1933, in the small town of Villa González Ortega in the state of Zacatecas, Mexico. He first learned about the bracero program from his older brother, Joaquín García. This photograph shows Joaquín García (left) and coworkers in the kitchen at the Buena Vista Labor Camp in Oxnard, California, considered the largest labor camp in the nation in 1958 with over 5,000 workers. (Courtesy of Lamberto M. García.)

In 1955, Lamberto M. García joined his brother Joaquín at the Buena Vista Labor Camp. During a visit to La Colonia Park, he watched the Oxnard All-Stars baseball team play against a visiting team. Through an interpreter, he asked for a tryout as a pitcher, and impressed the coach. As the only bracero on the team, he helped them win the tricounty championship. García continued playing baseball during return visits from Mexico, and because of his excellent pitching, was recruited to join the semipro Oxnard Braves. Here, Garcia is enjoying batting practice on the corner of C Street and Wooley Road where Driffill Elementary School is located. (Courtesy of Lamberto M. García.)

At the end of the bracero program, Lamberto M. García arranged his immigration papers with the help of Fidel Villaseñor, the owner of the Buena Vista Labor Camp, and brought his family from Mexico to Oxnard. He found a factory job and convinced his employer to sponsor his new baseball team, Los Pericos. (Courtesy of Lamberto M. García.)

Samuel Camacho was born in 1926 in Barranca de Oro, Nayarit, Mexico, and at 14, he left home to work for his uncle's bakery in San Miguel, Sinaloa. The skills he acquired in the bakery worked in his favor when he became a bracero. In 1947, he enlisted in the bracero program, picking lemons in Anaheim and later for the Oxnard Citrus Association. Due to his baking skills, he was hired to be the head cook at the Pacific Camp. This 1957 *Report on Bracero Feeding Standards* features Camacho on the front cover ringing the dinner bell at Pacific Camp. The guide instructed camp owners to hire "cooks who are skilled in the preparation of Mexican food." As the head cook, Camacho worked long hours every day of the week, including weekends, but was allowed to create his own menu and cook delicious Mexican food that reminded braceros of home. (Courtesy of Samuel Camacho.)

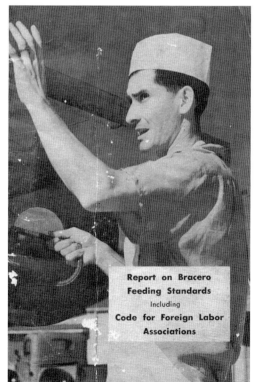

Report on Bracero
Feeding Standards
Including
Code for Foreign Labor
Associations

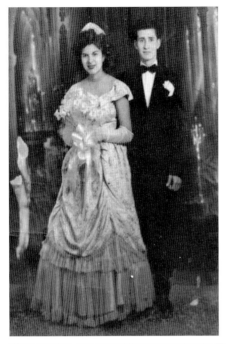

On January 20, 1951, Samuel Camacho married Consuelo Moreno, a Mexican American woman from El Rio, California. They met when Moreno and her friend were selling queen tickets at Pacific Camp for the Mexican Independence Day celebration. Braceros often courted and married local Mexican American women despite disapproving local Mexican American men who already felt displaced from the labor market. In the 1950s, Camacho became the purchasing manager at the Buena Vista Labor Camp. In 1971, he became camp manager at Triple S Labor Camp, which housed 180 workers who worked for the Somis Lemon Association, Seaboard Lemon Association, and Santa Clara Lemon Association. In 1986, with the help of Consuelo, three sons, and one daughter, Camacho purchased the Triple S Labor Camp, and the family operated the business until 2000. (Courtesy of Samuel Camacho.)

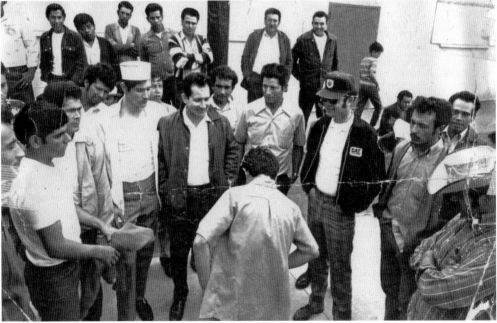

After the bracero program ended in 1964, Samuel Camacho was promoted to manager of Pacific Camp, owned by Coastal Growers Association. He lived on the camp premises with his family alongside single Mexican men who worked for the local citrus industry. He provided room and board, a shrine dedicated to La Virgen de Guadalupe, a cafeteria that served Mexican-style food, bathing and washing facilities, and recreational facilities. This photograph shows Camacho and Rafael de León surrounded by camp residents. (Courtesy of Samuel Camacho.)

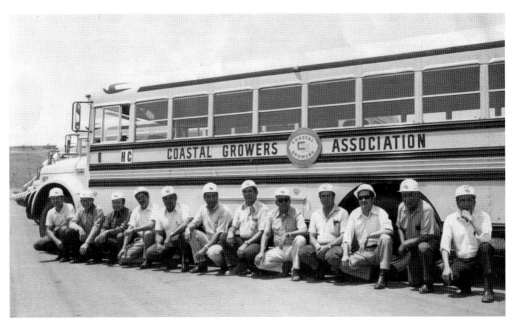

This 1972 photograph features the field foremen and camp managers for the Coastal Growers Association. Each one had a license to drive one of the 50 buses available to transport workers to and from the citrus orchards. Samuel Camacho was charged with recruiting workers from Mexico, so he brought several hundred from Tlazazalca and Yerbabuena, Michoacán, to work for local citrus associations. In 1982, the United Farm Workers union negotiated a contract with Coastal Growers Association, which opted to disband and sell off the camp property. From left to right are Rafael de León, Jack Loyd, Merced Raya, Jesús Díaz, Albino Rodríguez, Fidel Sánchez, Esequiel Zavala, Félix Velásquez, Gabriel Romano, Samuel Camacho, Bonifasio García, and Jesús Ríos. (Courtesy of Samuel Camacho.)

When his father died in 1951, Ignacio "Nacho" Guevara left San Luis Potosi, Mexico, to enlist as a bracero. He worked in Rancho Cucamonga and then transferred to the small citrus town of Piru, California. He began picking lemons and oranges for the Fillmore-Piru Citrus Association and then became a cook for the Piru Labor Camp, known as "El Campito." This photograph of El Campito includes bunkhouses with four beds to a room, a dining hall, bathroom and laundry facilities, and a swimming pool. (Courtesy of Mary Guevara.)

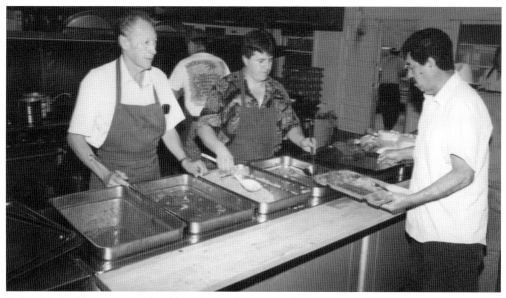

Before Nacho Guevara completed his 18-month contract, he met Mary Guevara, and they eloped to Sacramento. After several years trying to find work, he found a job with an employer who sponsored his application to become a permanent resident. Mary helped him learn English, and he later returned to his cooking job for several labor camps in Ventura County. After the bracero program ended, citrus growers faced a severe labor shortage, so they began recruiting ex-braceros to return with the promise of better wages, housing, and other benefits. (Courtesy of Mary Guevara.)

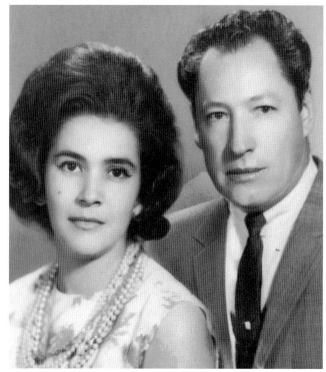

After 1964, many ex-braceros returned to Piru Labor Camp, now managed by the Guevaras, who provided subsidized meals, and after the 1986 Immigration Reform and Control Act, helped hundreds to adjust their immigration status. He organized baseball and soccer teams that played rival labor camps in Ventura County. In 1988, the Guevaras purchased the labor camp from the Fillmore-Piru Citrus Association, and operated it until 2003. In 2007, the Cabrillo Economic Development Corporation purchased the camp property to build affordable farmworker apartments and a soccer field. (Courtesy of Mary Guevara.)

J. Encarnación Alamillo was born in 1916 in Cueva Grande, Zacatecas, Mexico. When he was 12 years old, his father was killed in the Cristero Rebellion of 1928, and he had to take care of his mother and younger siblings. In the early 1940s, he married Guadalupe Villalobos Alamillo and started a large family of four boys and seven girls. The older boys, Jose and Rodolfo, are pictured here. In 1958, a severe drought wiped out the entire harvest, forcing him to leave his family and enlist in the bracero program. He was sent to a bracero camp in Salinas, where he could not get a good night's sleep because of the poorly made beds, the hot weather, and crowded conditions. He worked for six months picking strawberries, lettuce, plums, and tomatoes. After fulfilling his contract, he returned to Zacatecas and used his earnings to purchase a small piece of land for his family. (Courtesy of José Alamillo.)

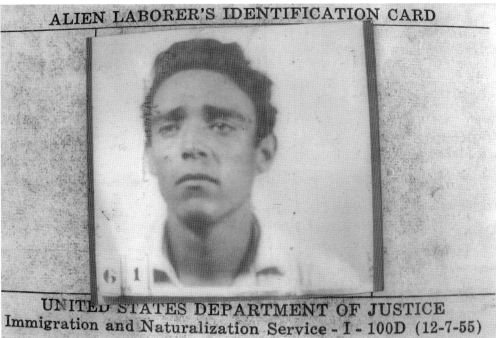

Basilio Alamillo was one of nine men, including Encarnación, from Cueva Grande, Zacatecas, who enlisted in the bracero program. He was contracted twice, first in 1950 to pick cotton in New Mexico, Texas, and Arizona, and again in 1958 to pick strawberries in Tracy, California. This *mica* card of Basilio shows his number, birth year of 1934 in Valparaiso, Zacatecas, and the year he was contracted. One day he skipped his contract, telling the guard he was going to the store, but his brother picked him up and drove him to Santa Paula. (Courtesy of Basilio Alamillo.)

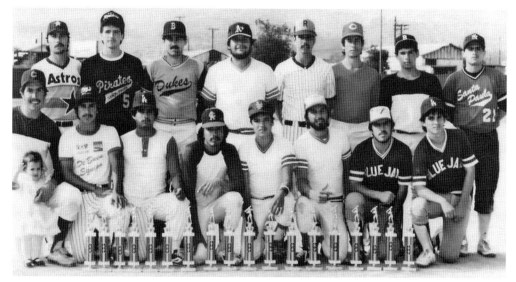

Sons, grandsons, and relatives of J. Encarnación and Basilio Alamillo formed a baseball team in Santa Paula in the early 1980s to pay tribute to family members who enlisted in the bracero program and to their hometown of Cueva Grande, Zacatecas. From left to right are (first row) Juan Antonio Alamillo with daughter, Benjamín Alamillo, two unidentified, Aureliano Reséndez, Nieves Meza, Ismael Robles, and Inés Alamillo; (second row) two unidentified, Julián Meza, Basilio Alamillo, Rigoberto Reyes, Maguello Alamillo, Rafael Alamillo, and Bobby Alamillo. (Courtesy of José Alamillo.)

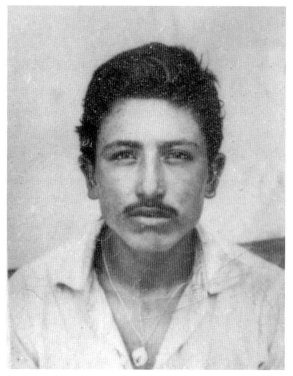

Growing up in Silao, Guanajuato, Mexico, Daniel Molina worked on the farm caring for his poor family. In 1959, he joined his uncle in the bracero program, and he remembered running out of water during their arduous train ride to Empalme, Sonora. They used their cowboy hats to catch rain water and quench their thirst. He waited in long lines for three days before paying a bribe to be selected for the bracero program. He remembered how braceros got food poisoning at a camp in Linden, California. He worked on and off in the San Joaquin Valley, picking fruits and vegetables until 1962 and after the program moved to Fillmore to work in the citrus industry. (Courtesy of Daniel Molina.)

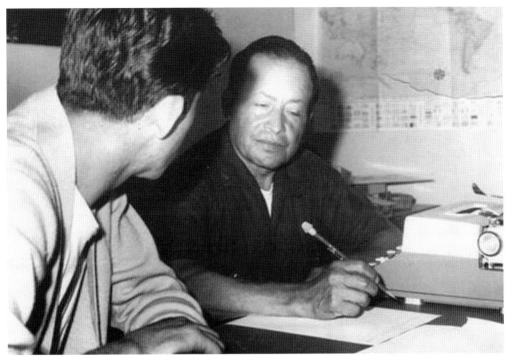

Merced Raya worked his way up from bracero to foreman and special advisor for the Coastal Growers Citrus Association in Oxnard. He learned English at adult school and helped braceros with translation, immigration problems, and financial advice and also developed a counseling program and camp library. In this photograph, he is counseling a bracero about personal issues. (Courtesy of Maria Collier.)

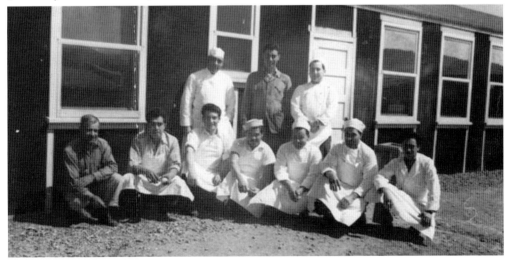

Merced Raya invented a "single-clip" clipper for lemons and oranges that helped Sunkist Growers increase productivity by 20 to 30 percent. He advocated for more recreational programs in labor camps, especially during baseball season. Growers agreed to hire a person to organize an ongoing baseball schedule, with at least one game every evening. (Courtesy of Maria Collier.)

Although he grew up playing soccer in Mexico City, Rodolfo Fragoso Oliva learned to play baseball when he enlisted in the bracero program. His dream of becoming a pilot was interrupted when his father became ill, requiring him to drop out of flight school and enlist in the bracero program in 1951. For five months, he picked cotton in Dumas and Watson, Arkansas. On Sundays, he joined a bracero team to play against a white American baseball team in an open field. Camp managers, however, enforced the color line in baseball and prohibited them from playing against African American teams. (Courtesy of Rodolfo Fragoso Oliva.)

Baseball helped bridge differences between braceros and Mexican Americans. Belen Soto Moreno and her sister Carmen Soto Cordova grew up in Litchfield Park, Arizona, next door to a bracero camp. Braceros taught Belen and Carmen how to play baseball using a stake as a bat and gloves made of canvas and cotton. Carmen formed a girls' softball team in Litchfield and continued playing in the women's softball leagues in Phoenix. Belen Soto Moreno (third from left) plays baseball with friends. (Courtesy of Bracero History Archive No. 3049.)

As a company foreman, Ramón Soto supervised braceros picking cotton, and his wife cooked Mexican meals for braceros as a form of supplemental income but also to make them feel at home. Ramón and his sons formed a band and performed at community dances for braceros. He would jokingly tell them "I wish you were as good workers as you are good dancers." They also performed at Mexican Independence celebrations before and after the queen coronation and street parade. This 1936 photograph shows the truck in the parade with both Mexican and American flags, reflecting an emerging Mexican American identity of second-generation residents. (Courtesy of Bracero History Archive No. 3043.)

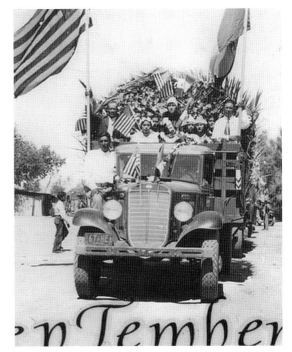

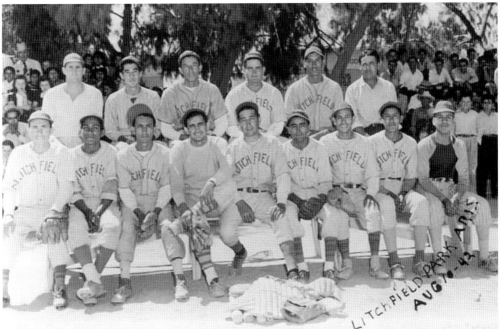

Litchfield Park, Arizona, was a company town founded in 1916 by Paul Litchfield, an executive with Goodyear Tire and Rubber. The company was later renamed Goodyear Farms. They sponsored Los Diablos, providing transportation, uniforms, and equipment. The team represented Litchfield Park with pride, especially when they defeated rival teams in the other towns. (Courtesy of Hayden Chicano Research Collection.)

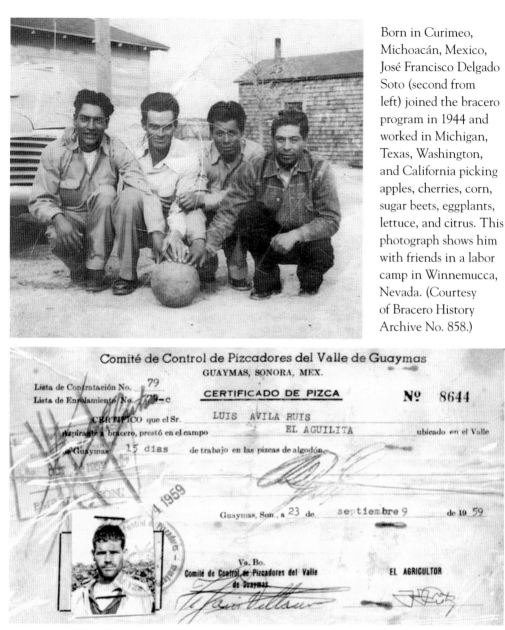

Born in Curimeo, Michoacán, Mexico, José Francisco Delgado Soto (second from left) joined the bracero program in 1944 and worked in Michigan, Texas, Washington, and California picking apples, cherries, corn, sugar beets, eggplants, lettuce, and citrus. This photograph shows him with friends in a labor camp in Winnemucca, Nevada. (Courtesy of Bracero History Archive No. 858.)

Luis Avila Ruiz was born on March 13, 1927, in Jaripo, Michoacán, Mexico, and enlisted in the bracero program from 1944 to 1946. Before he received approval, however, he was required to pick cotton for several months in Guaymas, Sonora, as part of Mexico's overlooked domestic bracero program. This is his contract to work in Sonora's cotton industry before crossing the US-Mexico border to work in the agricultural fields of Oxnard, Stockton, Delano, Gilroy, Salinas, Sacramento, Arizona, and Las Cruces, New Mexico. He was paid 65¢ per hour and recalled how in Las Cruces he received a paycheck for $3 after deductions for boarding and food costs. This made it difficult to support his large family in Michoacán. In 1972, he returned to the United States legally and settled his family of nine children in Oxnard. (Courtesy of Irma Avila.)

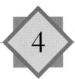

SANTA MARIA VALLEY

The Santa Maria Valley, a predominantly agricultural area, drew many Mexican farm laborers in the late 1930s and early 1940s. The region features beautiful weather for almost the entire year, which provides perfect conditions for recreation and family gatherings. A Saturday or Sunday afternoon would be filled with barbecues, picnicking, music, and sport. Baseball provided fun and exercise for large groups away from the rigorous routine of a hard week of labor. In makeshift fields and with limited equipment, sportsmen and family members entertained themselves until the sun went down.

In the 1950s and 1960s, the Santa Maria Valley experienced a tremendous growth in youth baseball. Kids of all ages were able to participate in organized ball, such as Pee Wee League, Little League, Middle League (now Babe Ruth), and American Legion.

The communities of the valley embraced this endeavor. Local merchants and businesses like gas stations, grocery stores, restaurants, and farming businesses saw this as a twofold opportunity. Not only would it provide needed advertising through the uniforms they provided, which helped business, but it also encouraged the community to be involved in social gatherings.

Family participation in baseball provided a path for younger generations to follow. It helped steer them away from the agricultural fields and to avenues for a better education. The talents that ensued provided an inroad in breaking the discrimination barrier the first generation experienced. More and more Mexican American players entered organized leagues from Little League to high school, college, and semipro, and some made it to the professional level, all with the same enthusiasm as their forefathers. Who doesn't remember putting on that first uniform, that first hit, that first catch, and running around the bases on that first home run?

Little League, along with other organized youth leagues, provided important life lessons. Baseball helped develop teamwork, sportsmanship, discipline, and dedication. Many individuals from the aforementioned generation went on to become coaches, umpires, officials, and mentors. They donated their time and money to the game of baseball they all learned to love.

Although this 1928 team is not in the Santa Maria Valley, there is a connection. The Gómez brothers (John, second row, second from right, and Manuel, first row, third from left) who helped lead Lemoore and Hanford team to a championship, are the father and uncle respectively of Dee Almaguer, who married into the Almaguer family, and she herself was very sports-minded. She is pictured on page 65 with her softball team winning a championship. (Courtesy of Gloria Almaguer Rucobo.)

Shown here is a 1930s church team from Guadalupe. This team is filled with several Almaguer brothers, notably Tony, Carmel, Reyno, and Jesse Almaguer. Also pictured, in no particular order, are teammates Toby Hernández, Julián Manríquez, Lawrence Zepeda, Leo Gondolfi, and Irving Alliani. (Courtesy of Gloria Almaguer Rucobo.)

Although not individually identified, there are four Almaguer brothers (possibly Manuel, Carmel, Luís, and Reyno) on this 1930s team. It shows their love of the sport, as they traveled long distance to play for a Pacoima team. (Courtesy of the Almaguer family.)

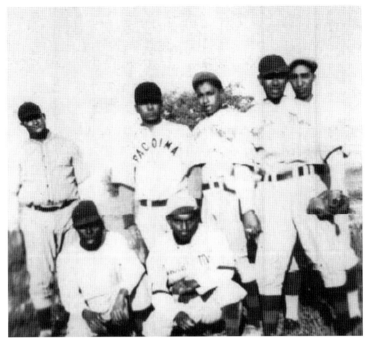

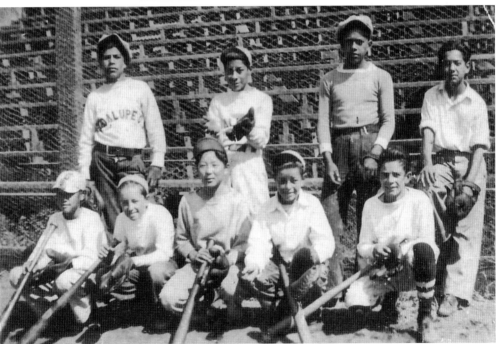

This 1937 Guadalupe youth team played on this field, the first in the Santa Maria Valley to have lights installed for evening games of baseball and softball. From left to right are (first row) Bill Kasiwagi, Donald Nuñez, Maso Goto, Victor Lanini, and Henri Raynaud; (second row) Manuel Estrada, Carmel Almaguer, Toby Hernández, and Porfiro Arellanes. (Courtesy of the Almaguer family and the Guadalupe Education and Cultural Center.)

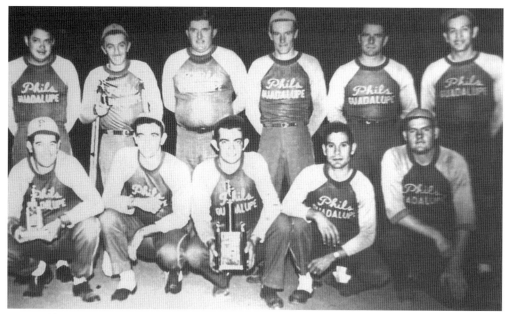

Pictured here is a 1940s Guadalupe softball team, the Phils. Francis Rojas, second row, far right, not only led his team but was also fully involved in youth baseball as a coach and umpire. He helped coach a women's team, the Guadalupe Rocketts, in 1944 and 1945. (Courtesy of Betty Silva, Al Ramos, and the Guadalupe Education and Cultural Center.)

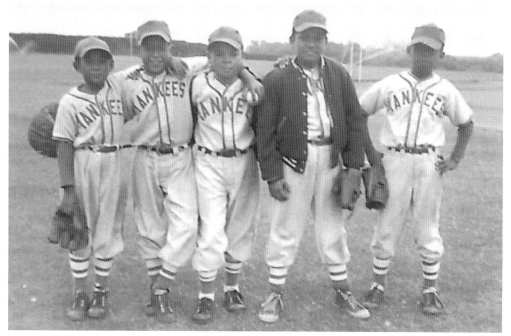

Here are a few of the members of the 1952 Yankees, the first year of organized Little League in Guadalupe. From left to right are Jimmy Arriola, Milo Lizalde, Jimmy Santiago, Charlie Rivas, and Andy Álvarado. (Courtesy of Jimmy Santiago.)

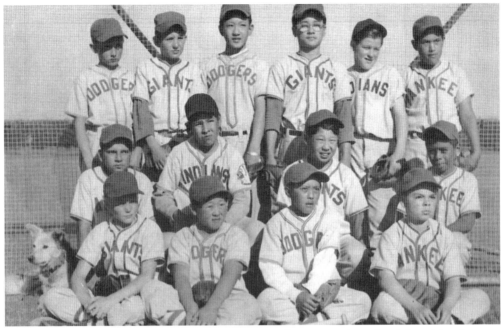

Seen here are the 1953 Guadalupe All-Stars, the first all-star team from Guadalupe. The diversity of this small community of 2,500 is shown in this picture, with Japanese, Filipino, Mexican American, and Anglo players. From left to right are (first row) team mascot Sandy, Rex Bewley, Hiroshi Kitagawa, Richard Amido, and Jim Santiago; (second row) Charles Rivas, John Sabedra, Ron Sahara, and Andy Álvarado; (third row) Clifford King, Mark Thornton, Richard Miyake, Ken Miyamoto, Jack Frazier, and Herb Lizalde. (Courtesy of Jimmy Santiago.)

These 1954 Guadalupe Little League friends, from left to right, are James Florita, Nick Ugsang, Albert Cortéz, and Fernando Ramírez. The adult holding daughter Valerie is Frank Cortéz. (Courtesy of Fernando Ramírez.)

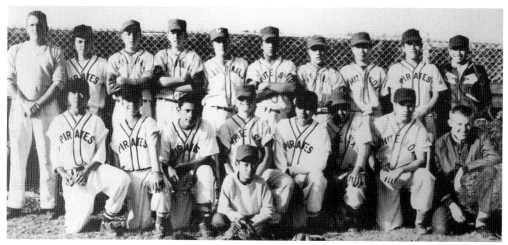

Pictured here are the 1956 Guadalupe Middle League All-Stars. From left to right are (first row) Richard Amido, Michael Rojas, Milo Lizalde, Dan Danieli, Tony Ruiz, Charles Rivas, John Sabedra, and coach Larry Goins; (second row) manager Gene Arnoldi, James Santiago, Jon Brunner, Mark Thornton, Jack Frazier, Sotero López, Richard Sahara, Ronnie Sahara, Herbert Lizalde, and coach Ron Estabillo. The batboy is Richard Sahara. (Courtesy of the Guadalupe Education and Cultural Center.)

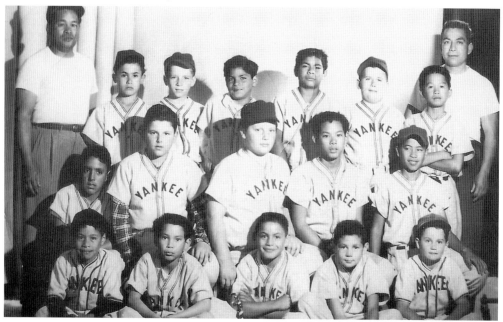

This 1956 Little League Yankees team was coached by Leo Julián and Tony Almaguer. Tony, who passed away in 2015, dedicated the majority of his life to coaching youth sports. From left to right are (first row) Aristón Julián, Claudio Arriola, Lenny Lizalde, William Armarillas, and Burgess Wetta; (second row) Ángel Lemus, Johnny Samonte, John Villa, James Arriola, and Victor Cabatuan; (third row) coach Leo Julian, Tommy Lara, Danny Robinson, Ángel Rivera, Robert Almaguer, Allan Texiera, James Florita, and coach Tony Almaguer. (Courtesy of Tommy Lara.)

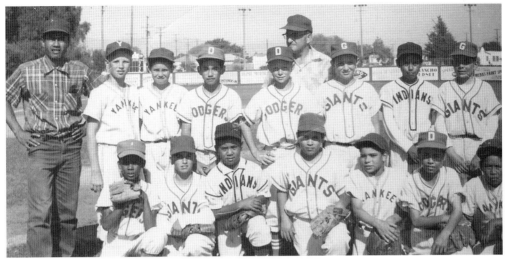

This is the 1959 Guadalupe All-Star team. From left to right are (first row) Roosevelt Campbell, Peter Ramos, Jimmy Castillo, Louis Ayala, George Rivas, Geoff Villegas, and Ariston Julián; (second row) coach Ron Estabillo, Larry Pritchett, Burgess Wetta, Eddie Bernardo, Ron Rhinehart, John Gropetti, George Real, Mark Fantino, and coach Alex Testino. One constant theme with this youth sports team is the same core of coaches who dedicated their precious time to work with the youth in the community. (Courtesy of Al Ramos.)

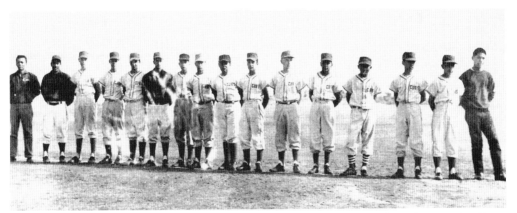

The 1962 Guadalupe Middle League Cubs won 22 consecutive games and two league titles. From left to right are coach Fred Amido, coach Ron Estabillo, Larry Pritchett, Tony De La Cruz, John Gropetti, Peter Ramos, Mark Fantino, Chris Zarate, David Sánchez, Henry Sánchez, Sammy Cook, Richard Noriega, Danny Tesoro, Geoff Villegas, John Lizalde, and Ariston Julián. Julián went on to win sports awards in high school and college and later became mayor of his hometown of Guadalupe. Lizalde signed a professional contract with the Los Angeles Dodgers and is currently mayor of Guadalupe. (Courtesy of the Guadalupe Education and Cultural Center.)

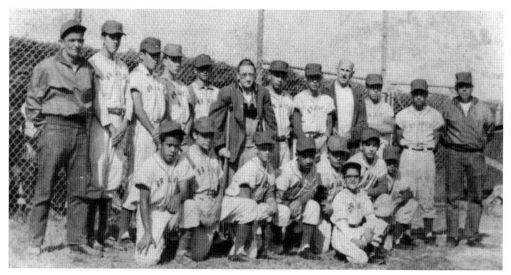

Many of these players on the 1962 Guadalupe Middle League Braves later played at Righetti High School. From left to right are (first row) Jim Castillo, George Rivas, Lloyd George, Jaime Francisco, Lloyd Sherrill, Frank Ayala, Ronnie Rhinehart, and unidentified batboy; (second row) Leo Gondolfi, Robert Haro, Greg San Diego, David Shaeffer, Burgess Wetta, Alex Testino, Butch Bernardo, unidentified, Charles Draper, Frank Martínez, Ed Bernardo, and coach Dan Arvizu. (Courtesy of the Guadalupe Education and Cultural Center.)

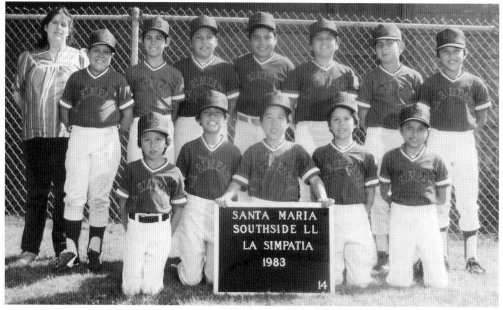

Shown here is the next generation of players with continued sponsor support by a famous local restaurant in Guadalupe, La Simpatía. From left to right are (first row) Tommy Solís, Joe Albert Ruiz, Louie Hin, Willie McCormack, and Javier Rubacalva; (second row) Estella Salinas, Israel Marisal, DeJesus Chávez, Fernando García, Tony Domínguez, Brian Flores, unidentified, and Robert Seja. (Courtesy of Rosie Quiroga.)

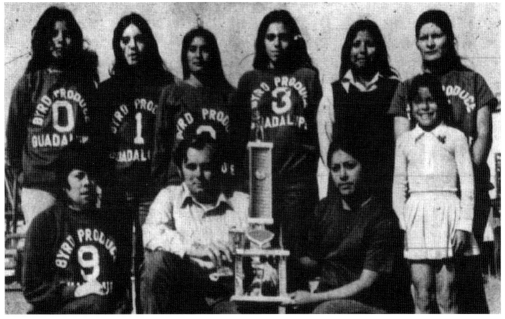

The Guadalupe Byrd Produce women's softball champs are seen here in the late 1970s. From left to right are (first row) Dee Almaguer, sponsor rep Vic Leedy, Carol Lizalde, and team mascot Denise Regalado; (second row) Helen Real, Terry Navarro, Maggie Rubacalva, Rosann Real, and Martha Regalado. Not pictured are Linda Souza, Mary Aguirre, Connie Real, Hope Rodríguez, Rachel Ramírez, and Alice Ramírez. This team was truly a family affair, with the Real sisters, the Ramírez sisters, and Dee and Martha, who were sisters-in-law. (Courtesy of Gloria Almaguer Rucobo.)

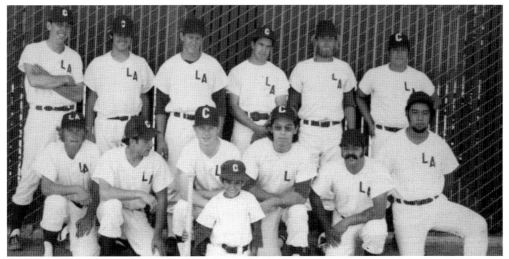

The 1972 Los Alamos Cowboys are, from left to right, (first row) Mike English, two unidentified, Pete Miranda, José Sosa, and Mike Hernández; (second row) Bill King, two unidentified, Javier Díaz, unidentified, and player-manager León López. León López was an outstanding athlete not only in baseball but also in track and basketball. He was a successful businessman, so he sponsored this team. (Courtesy of the León López family.)

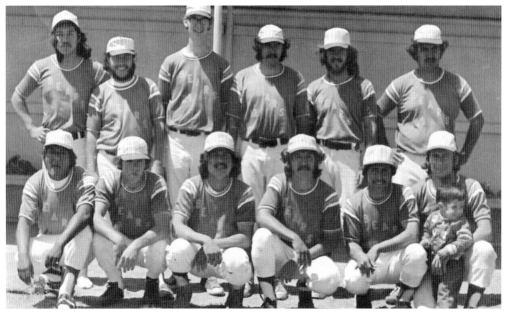

Seen here are the Santa Maria Bears in 1973. From left to right are (first row) Leo Padrón, R. Tognetti, Cesar Ramos, Mike Ramos, Don Pack, and manager Al Ramos with son Chris; (second row) Henry Delgado, Manuel Bustamonte, George Clark, Ralph Rubio, Mike Meehan, and Sal Gómez. (Courtesy of Al Ramos.)

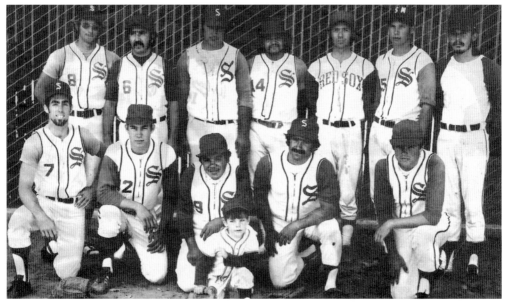

The Valley League Red Sox, pictured here in the 1970s, are, from left to right, (first row) Allen Hire, Denny Bunch, Gene Aragón, Mike Hernández, Chip Copper, and batboy Tim Hire; (second row) Larry Speck, Rudy Gálvan, Frank Azevedo, Tony Valero, Dan Robinson, Donny Bunch, and Rick Ambrosi. This team was one of the original members of the Valley League, formed in 1960. (Courtesy of Rudy Gálvan.)

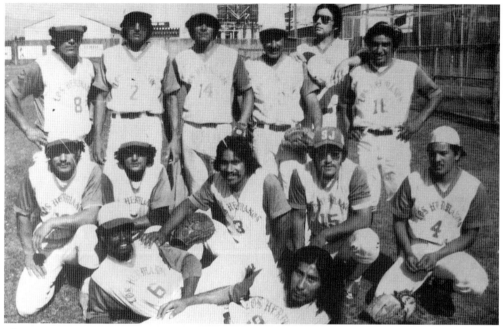

The Nipomo Los Hermanos team won the 1974 Valley League championship. They are, from left to right, (first row, lying down) Horace Glenn and Steve Peñaflor; (second row) manager John Peñaflor, Rene Arriola, Rick Peñaflor, coach Ernie Anaya, and Sammy González; (third row) Danny Castillo, Kenny Lundgren, Frank "Kiki" Domínguez, Alex Rodríguez, Frank Rodríguez, and Arturo Rodríguez. (Courtesy of Rudy Gálvan.)

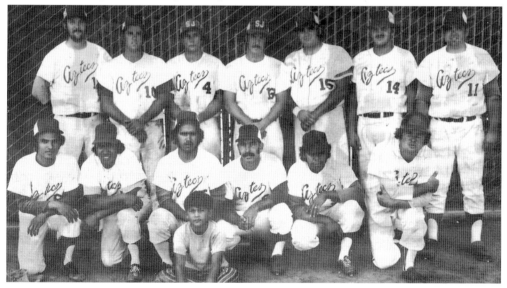

Pictured here are the 1973 Santa Maria Aztecs; from left to right are (first row) Ron Zarate, Kai Francisco, Alfredo Gonzáles, Pat Rogers, Rubén Peinado, Richard Olivera, and batboy Steve Márquez; (second row) David Usery, Mike Goggan, Tim McDonald, Danny Zarling, Gordon Dutra, Mike Hulbert, and manager Jack Copple. (Courtesy of Rudy Gálvan.)

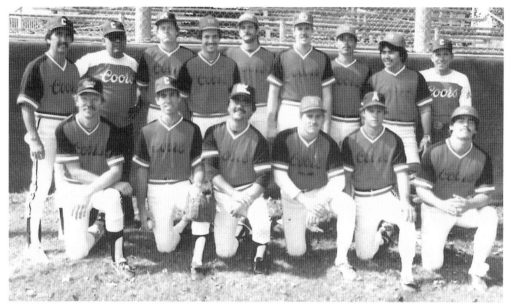

The 1983 Central Coast Cavaliers, champions of the Tri-County League, were a descendant of the Valley League Red Sox of the 1960s and 1970s. Players like Rudy Gálvan (second row, far left), Louie Olivo (second row, second from left), and James Bartlett (second row, far right) were members of the early Red Sox teams. (Courtesy of Rudy Gálvan.)

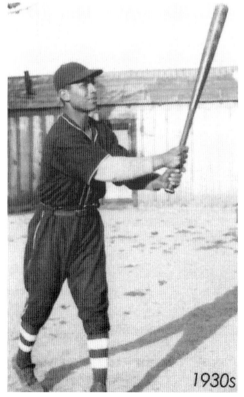

Upon arriving in the Santa Maria Valley, the Almaguer family settled on a ranch outside the city of Guadalupe. One of the sons, Tony, quickly earned some notoriety as a boxer in his teens. In deference to his mother, he quit the ring and went to work in the fields with his brothers. Tony, along with several brothers, played various sports throughout the Santa Maria Valley. He is seen here in the 1930s with one of the many baseball teams he played for during his extraordinary career. He was one of the first to be inducted into the Guadalupe Sports Hall of Fame in 2004 for coaching and boxing. Tony and his family were great contributors to youth baseball and other sports. He was an important asset to the community. He also coached basketball and led teams to several championships. He passed on his passion for sports to both family and community members. He passed away on January 26, 2015, at the age of 101. (Courtesy of the Almaguer family.)

SANTA MARIA VALLEY

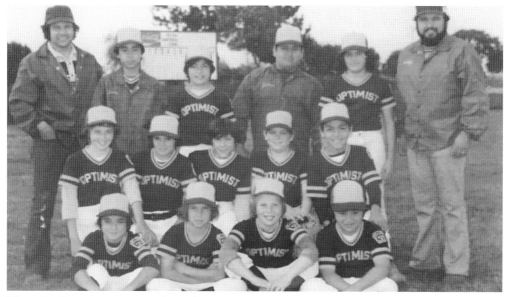

The 1977 Santa Maria Westside Little League Optimists won the city championship. From left to right are (first row) Anthony Cedillos, unidentified, Tyrone Chrest, and Joel Moreno; (second row) Matthew Martínez, Eddie Schubert, Todd Amarillas, Randy Aliani, and Ron López; (third row) coach Sal Baldiviez, Jesse Hernández, Henry Sapien, Julian Cruz, Michelle Pérez, and manager Mickey Prado. Michelle Pérez was the first girl to play Little League in Santa Maria. (Courtesy of Eddie Navarro.)

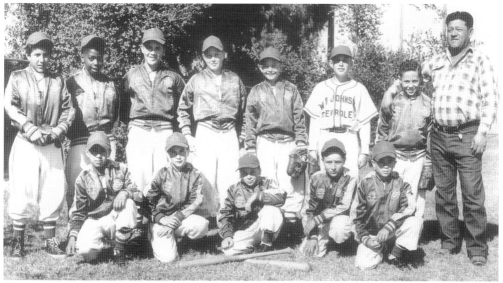

Seen here is the 1953 Santa Maria Little League W.B. Johnson Chevrolet team. Ernie Baldiviez (second row, left) went on to coach Little League and St. Joséph High School girls' softball for many years, winning three league titles and two California Interscholastic Federation titles in 1987 and 1988. Lou Borges (second row, third from left) was a very successful high school pitcher who went on to coach youth baseball at several levels. Also pictured are coach Eddie Pacheco (second row, far right) and Gerald Rodríguez (first row, second from right). (Courtesy of Eddie Navarro.)

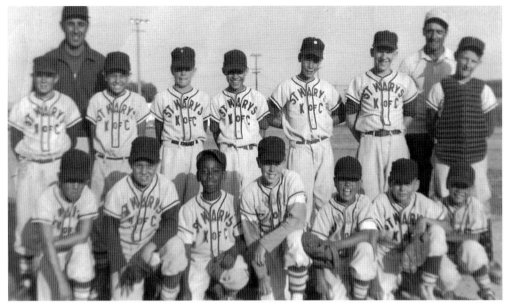

The 1957 St. Mary's team included, from left to right, (first row) Doug Casselman, Tom Muscio, Jimmy Williams, Robert Carlson, Henry Pantoja, Roger Clark, and Anthony Pantoja; (second row) George Hamil, Sal Baldiviez, Mike DeRosa, Robert Martínez, Dave DeRosa, Brian Clegg, and Richard Smith; (third row) coaches Smokey Silva and Al Pimentel. This team, sponsored by St. Mary's Catholic Church, took first place. (Courtesy of Eddie Navarro.)

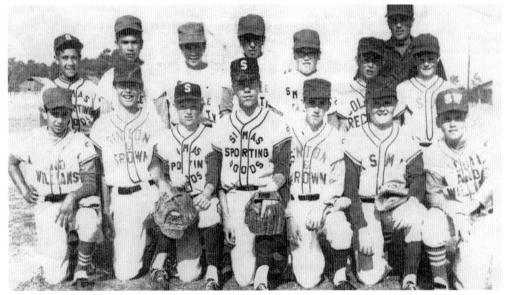

The 1969 Santa Maria Northside Little League All-Stars are, from left to right, (first row) Rick Baldiviez, Len Salazar, unidentified, Richard Edie, and three unidentified; (second row) Rudy Rodríguez, unidentified, Wayne Crabtree, Joe Béndele, and four unidentified. This was the first year for the Northside Little League. Joe Béndele, nephew of Paul Béndele (one of the valley's finest pitchers) helped take his team far in the Little League playoffs. (Courtesy of Eddie Navarro.)

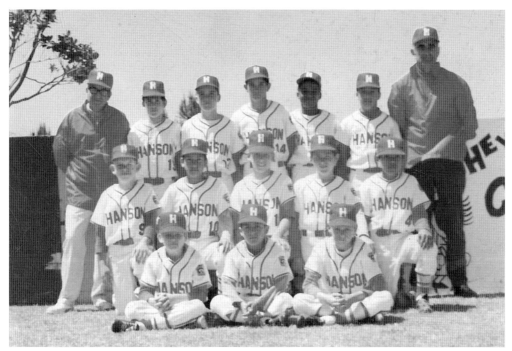

The 1970 Hanson Equipment team is, from left to right, (first row) Glen Coll, Tim Domínguez, and Doug Parker; (second row) Tim Korth, David Torres, Greg Timmons, Frits Wedgeworth, and Ernie Trujillo; (third row) coach Stan Carr, Mark Silva, Keith Bell, Keith Hartman, Kendall Greene, Mark Domínguez, and coach Smokey Silva. Mark Silva and Kendall Greene pitched their team to the league championship. Kendall is now a captain in the Santa Maria Police Department. This team won three consecutive Westside League championships. (Courtesy of Mark Silva.)

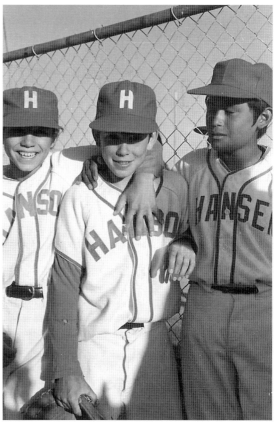

The 1969 Hanson Equipment team featured, from left to right, Doug Murray, Mark Silva, and George Ortiz. This group of kids went on to win their league championship. Mark Silva signed a pro contract and played with the New York Yankees farm team until arm problems forced him to retire. (Courtesy of Mark Silva.)

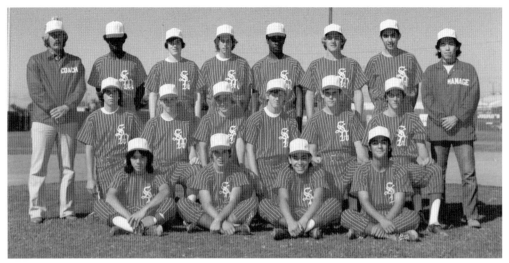

The 1974 Santa Maria All Stars are, from left to right, (first row) Art Zavala, unidentified, Muchie Marmolejo, and Tim Domínguez; (second row) John Rodríguez, Steve Weldon, unidentified, Keith Hartman, Mike ?, and Joe McGill; (third row) coach Ron Chrest, Ricky Johnson, Mark Silva, Mike Andrews, Eric Akins, David Gray, Mike ?, and manager Pete Miranda. Miranda played baseball as a youth, making several all-star teams. He also played in the Valley League as an adult and continued his involvement in the sport as a coach. Tim Domínguez went on to quarterback his high school team. Mark Silva signed a pro contract with the New York Yankees. (Courtesy of Mark Silva and Pete Miranda.)

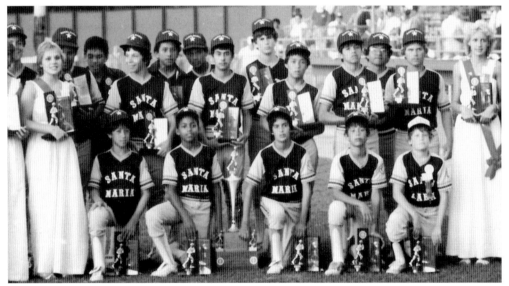

This 1983 Babe Ruth team is, from left to right, (first row) Matt Waggoner, Michael Pope, Billy Batiste, Kennedy Clark, and unidentified; (second row) David Yánez, Michael Rosales, Sergio Zepeda, Mark Sepe, Gilbert Díaz, and coach Scott June; (third row) Eddie López, Patrick López, Jaime Castillo, Henry Morín, Jason Lovera, and coach Larry Juárez. This team made it all the way to the national championship game, losing to a team from Michigan. (Courtesy of Sal Gómez.)

SANTA MARIA VALLEY

THE MERCED REGION

The Merced Region is a small area in the heart of California. It is 120 miles south of Sacramento and 167 miles north of Bakersfield. Besides Merced, other local communities include Atwater, Livingston, Hilmar, Winton, Snelling, Planada, LeGrand, Dos Palos, Los Banos, and Delhi.

Atwater is the home of Castle Air Force Base. Agriculture has historically been the primary source of employment and income for Mexican Americans. In the years prior to World War II, Mexican Americans had limited educational opportunities; only some attended high school and a handful went on to college. Children worked side by side on farms and in the fields with their parents. Very few trade jobs, let alone white-collar positions, were available to Mexican Americans.

Baseball and softball were weekly activities for Mexican American families. If it had not been for these sports, many young men might have found lots of mischief and trouble with law enforcement. Sunday afternoon was the best day for baseball as fans supported their local teams throughout the Central Valley. In Merced, families gathered at old Merced Bear Creek Field to watch their teams play against teams from Sacramento, Stockton, Modesto, and Madera. Meals were served after the game by the host team. Many friendships were formed by this yearly competition, resulting in crosstown marriages, baptizing each other's children, becoming *comadres* and *compadres*, and later, working together as allies for political, labor, and civil rights. Religion and family were the cornerstones of these Spanish-speaking communities.

On December 7, 1941, the Japanese attack on Pearl Harbor dramatically changed forever the life path for many Mexican Americans in the Merced Region. Merced High School students soon enlisted into the military, including friends Dave Contreras and Salvador Olivarez, two outstanding athletes who were about to sign minor league contracts. Their baseball dreams would have to wait until after 1945. Both Contreras and Olivarez came back and coached several Little League teams, including some players who went on to play professional ball. Teams that they coached included the Merced Pepsi, Merced Eagles, Planada Latin American Club, Merced Azteca, and Club Mercedes. Contreras was inducted into the newly formed Merced High School Athletic Hall of Fame in 2016.

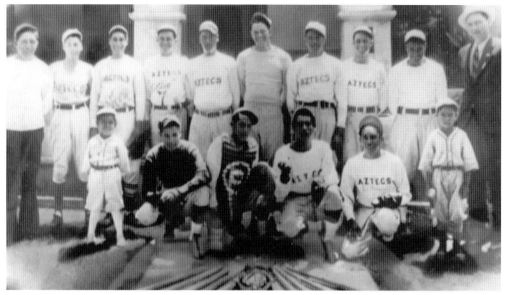

The 1935 Merced Aztecs baseball club was a powerful team. From left to right are (first row) batboy Ralph Mendoza, Nick Macías, Johnny Cárdenas, Smokey Hernández, Salome Olivarez, and batboy Eddie Gómez; (second row) David "Kid Buck" Rodríguez, coach Joe V. Martínez, Jesús Jiménez, Nacho Mariscal, Rudy Buendía, Nick Gonzáles, Johnny Mariscal, Jesse Contreras, Mat Jiménez, and manager Calistro Gálvez. (Courtesy of David Contreras Jr.)

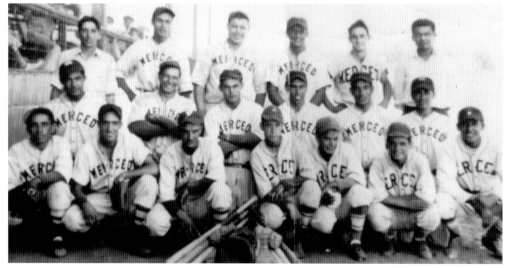

The 1937 Merced Eagles played their games at Bear Creek Field in Merced. From left to right are (first row) John Olivarez, Ray "Hot Feet" Septien, John Padilla, Eddie Gómez, Lester Martínez, Frank Martínez, and Pete Buendía; (second row) Jesse Padilla, Shuie Gonzáles, Tacho Moreno, Salvador "Chappo" Olivarez, Mike Hernández, and Primo Chávez; (third row) manager Salome Olivarez, Ysidro Mariscal, Román Contreras, David Contreras, Howard Cullen, and Raymond Contreras. The team was sponsored by various merchants, private donations, and team fundraisers. (Courtesy of David Contreras Jr.)

　　　　　　　　　　　　　　　　THE MERCED REGION

Brothers Raymond (left) and David Contreras pose before a game at Bear Creek Field in May 1937. Raymond was at first base, and David played second base and shortstop. There was a third brother, Danny, who was younger. He also joined the team a few years later. All three served in the military during World War II. Raymond and Danny were in the Navy, and David was in the Army. After the war, all three brothers returned home to the family. David married his high school sweetheart, Evelyn Soria, the day before Pearl Harbor was bombed. They had seven children. Raymond married Lupe Flores in November 1951. He and Lupe had two children. Danny returned from the war with medical problems and never married. In 1947, the brothers were instrumental in founding Club Mercedes Inc., a nonprofit social club for the community, their families, and their friends. Club Mercedes celebrated 69 years in April 2016. The second Contreras generation, along with 200-plus members, keep Club Mercedes alive and well. (Courtesy of David Contreras Jr.)

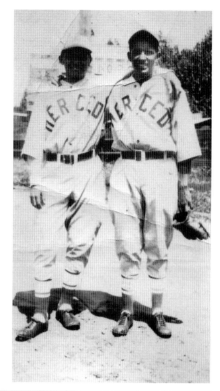

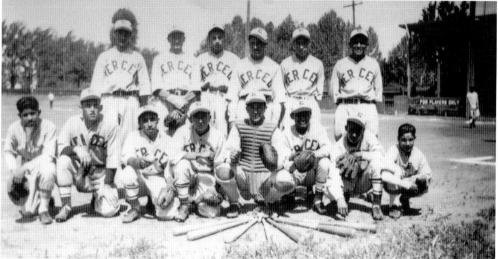

This is the Merced Eagles junior team in 1937 at Bear Creek Field. As in so many Mexican American communities, Merced's baseball teams had minor- or junior-league teams from which they would call up players in case of injuries or to improve the big club. This team was comprised of 16-to-20-year-olds. From left to right are (first row) Danny Contreras, Gail Phillips, Johnny Olivarez, Manuel Valverde, Harold Arancibia, Raymond Contreras, John Padilla, and batboy Frank Martínez; (second row) Earl Nursement, E.B. Alcorn, Ysidro Mariscal, John Mariscal, Salvador Olivarez, and David Contreras. (Courtesy of David Contreras Jr.)

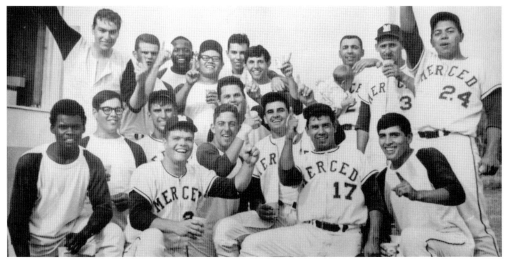

The 1967 Merced Community College team won the first major sports championship in school history with a record of 21-7. Several Mexican Americans played on this team, including Paul Gonzáles (No. 17), who played shortstop; John Montano (first row, far right), who pitched; Jeff Braga (second row, with glasses), also a pitcher; Bill Contreras (back row, fourth from left, holding cup), outfielder; Andy Tafoya (back row, fifth from left), first baseman, and Rene Marcos (back row, sixth from left), who played second base. The team beat Antelope Valley 2-1 for the championship. (Courtesy of Bill Contreras.)

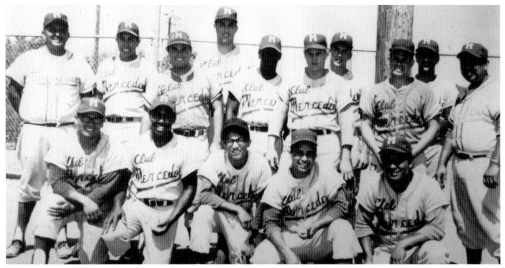

This is the last Club Mercedes hardball team in 1967, pictured at the Mexican American League championship. They defeated a strong team, the Madera Merchants, 1-0. From left to right are (first row) Bill Contreras, Carl Mays, Les Contreras, Johnny Olivarez Jr., and Steve Contreras; (second row) manager David Contreras, Joe Pangelina, Dave Mendoza, Danny Guzmán, Bob Rollins, Charlie Visher, Howard Cullen, Jimmy Visher, Eugene Breinig, and coach Manuel Chávez. Guzmán, Jimmy Visher, and Breinig went on to play professional baseball. (Courtesy of David Contreras Jr.)

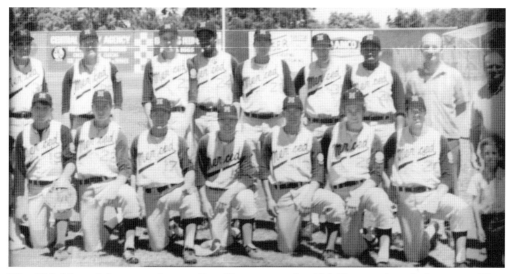

The 1971 Merced American Legion Post 83 team was the 12th District Area 3 champion. They were the first team from Merced County to quality for the American Legion state tournament in Yountville, California. This photograph was taken at Billy Hebert Field, home of the Stockton Ports. From left to right are (first row) Mike Perino, Billy Morgan, Bobby Dallas, Tommy Dallas, David Contreras, Doyle May, John Devaurs, and batboy Micky Berklich; (second row) coach Richard Juárez, Glenn Garvin, Jerry Garvin, David Brooks, Jim Slate, Stanley Roberts, Charlie Davis, coach Mike Berklich, and coach Larry Nelson. (Courtesy of David Contreras Jr.)

David Contreras (left) poses with sports columnist Murray Olderman. Contreras was inducted into the Merced County Hall of Fame on November 8, 1978. In 1936, he became the first Merced High School athlete to receive the coveted All-American Blanket. He received the honor again in 1937 and 1938 for football. His contributions to the community included Little League and Babe Ruth teams in the 1950s and 1960s. He built championship teams in the Central Valley Mexican American League, his last championship in 1976 with the Planada Latin American Club. He dedicated his entire life to baseball. He passed away on February 9, 1996. Several hundred attended his funeral to pay their respects. (Courtesy of David Contreras Jr.)

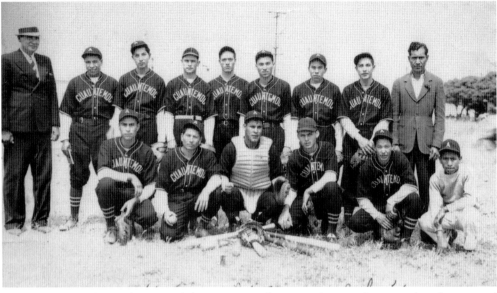

The 1940 Merced Cuauhtemoc Club was a powerhouse with several outstanding hitters and pitchers and often dominated opponents. From left to right are (first row) Mike Cervantes, John Órnelas Sr., unidentified, N. Moreno, unidentified, and Joe Flores; (second row) unidentified, Mato Jiménez, Frankie De La Fuente, ? Contreras, unidentified, Alfonso Mendoza, Hank Apodaca, Curley ?, and unidentified. (Courtesy of Gloria Órnelas Cuadros.)

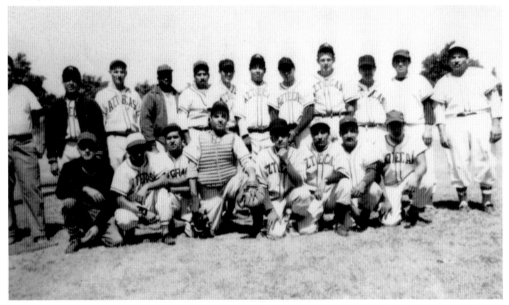

The 1930s Merced Aztecas are, from left to right, (first row) P. Marvin, Alfred Gutiérrez, Johnny Espinoza, Jesse Santillán, Ralph García, Duke Cárdenas, Frank Ybarra, and Robert Martínez; (second row) coach Pete Valdez, Joe Orozco, Don Faulkenberry, Arthur Abercremaie, Carlos García, Kelly Gálvez, John Órnelas Jr., Richard Flores, Ray Haley, Manuel Chávez, Paul Flores, and manager Johnny Órnelas Sr. (Courtesy of Gloria Órnelas Cuadros.)

THE MERCED REGION

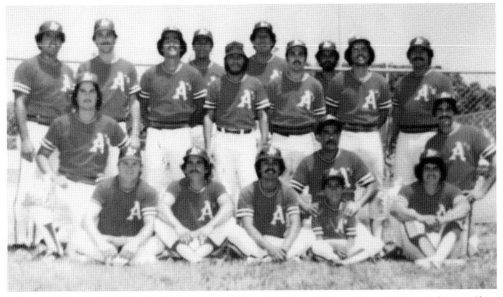

The 1979 Merced A's played their games at Merced Junior College. From left to right are (first row) Wayne Hague, Ponch Tejada, Tony Padilla, Félix Zuñiga, Félix Zuñiga Jr., and Eddie Flores; (second row) Rickey Peña and George Descalso; (third row) coach John Montano, Franny Oneto, Henry García, Auddie Green, Julio Pérez, Benjamín Flores, Alfred Velásquez, Holmes García, Aaron Peña, and coach Bob Mantano. (Courtesy of David Contreras Jr.)

This is a 1934 box score of a game between Merced and a visiting team from Berkeley, California. The Berkeley team won a close contest by the score of 3-2. Teams from Merced often traveled north throughout the Bay Area and Sacramento, as far south as Bakersfield, and to all the small towns in between, including Visalia, Turlock, Tulare, Porterville, and other Mexican American communities that bordered Highway 99. San Francisco fielded a Mexican American team called the Mexican Club in the 1930s. They played several teams from Mexico and against their archrivals from Sacramento, the Mexican American Club (MAC). The Sacramento MAC team in the 1930s, 1940s, and early 1950s was recognized as the dominant team in the Sacramento area and in Northern California. (Courtesy of Raymond Olivarez.)

MERCED	ab	r	h	o	a	e
Olivarez, lf	4	0	1	0	0	0
Smith, cf	3	2	2	1	0	0
Herlitz, 3b	4	0	1	0	0	0
F. Gutierrez, ss	4	0	2	5	4	0
Gonzales, c	3	0	0	10	2	0
M. Gutierrez, 1b	4	0	1	7	1	0
Hernandez, 2b	3	0	0	3	1	0
Ornealis, rf	3	0	0	0	0	0
Monges, p	3	0	0	0	0	0
	31	2	7	26	8	0

BERKELEY	ab	r	h	o	a	e
Flores, lf, 2b	3	1	0	2	0	0
Almada, ss	3	0	0	1	4	0
Valencia, c	4	1	1	10	1	0
A. Martinez, 1b	4	1	2	9	0	0
J. Martinez, rf	4	0	1	1	0	0
Mata, cf	4	0	1	0	0	0
Mattroda, 3b	1	0	0	2	0	0
Ramirez, 2b	1	0	0	0	0	0
Munos, p	3	0	1	0	1	0
D. Martinez, lf, 2b	1	0	0	2	2	0
Gomez, 2b	1	0	0	0	2	0
	32	3	6	27	10	0

Summary: Home run—Valencia. Two base hits—Smith 2, Herlitz and F. Gutierrez. Struck out—By Munos 10; by Monges 9. First base on balls—Off Munos 1; off Monges 3. Hit by pitcher—Smith by Munos. Stolen bases—Smith, F. Gutierrez and A. Martinez.

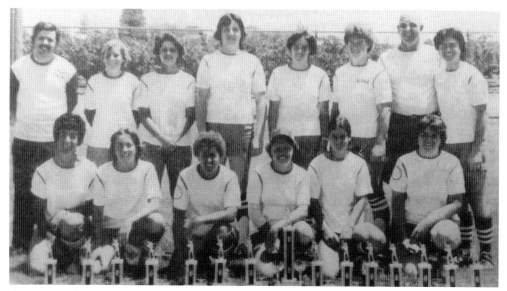

Sequoia Market sponsored the 1976 Bobcats of Ceres, California. The team won the Summer Women's Slow Pitch Tournament, sponsored by the Manteca Metropolitan Recreation Department. From left to right are (first row) Alice Coito, Sheila Lytle, Gerrie Bell, Charles Green, Bev Freitas, and Joyce Oliveira; (second row) coach Rich Berdion, Robin Berdion, Bev Bentley, Shelly Tramell, Leslie Lewis, Bonnie Mellor, coach Bob Earl, and Sylvia Lovato. Lovato also played sports at Merced Community College, including tennis, in which she earned the most valuable player award, and basketball. (Courtesy of Sylvia Lovato.)

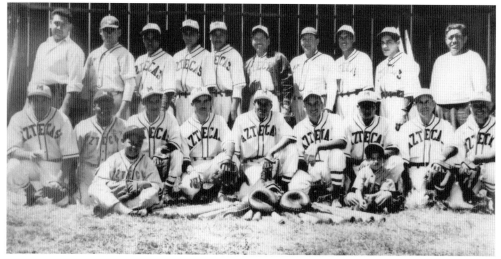

The Merced Aztecs had outstanding pitching, powerful hitting, and amazing fielding in the 1930s and 1940s. From left to right are (first row) Frankie De La Fuente, Joe Flores, Duke Cárdenas, ? Rocha, Hank Apodaca, Alfonso Mendoza, Gene Flores, ? Contreras, and ? Contreras; (second row) ? Chávez, ? Ochoa, Adolf Cárdenas, Frank Ybarra, John Órnelas Sr., ? Cárdenas, Tony Soriano, ? Cárdenas, and Buck ?. The batboys are John Órnelas Jr. and Alfonso Mendoza Jr. (Courtesy of David Contreras Jr.)

THE MERCED REGION

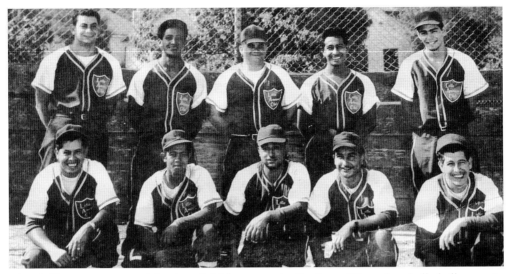

This 1952 team was one of the first Cal Mex teams in Stockton. They played all challengers in Northern California and brought the food and beer for the post-game celebration. One of the players, José Zaragoza, had played for a team in Woodland, California, called the Latin American Club. The Stockton team decided to adopt the same name. From left to right are (first row) Bruno Cardona, Manuel Catario, unidentified, Bill Velverde, and John Cardona; (second row) Santi Gardia, Primo Orasco, Andy Gardia, Sachus Orasco, and José Zaragoza. (Courtesy of Randy Zaragoza.)

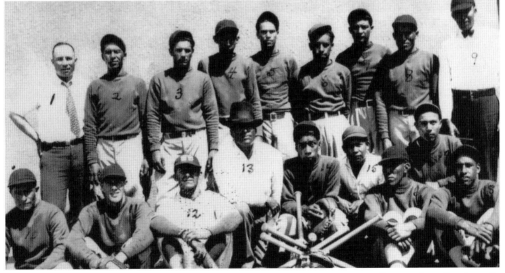

The 1934 Riverbank Merchants played near Modesto. Mexican roots run deep in Riverbank, with most people tied to the agriculture and railroad industries. As in many other communities, residents faced discrimination in housing, education, employment, and recreation. This photograph was taken in Merced. From left to right are (first row) C. Martínez, J. Bordona, R. Monges, manager and captain P. García, W. Francisco, batboy ? Carrillo, E. Hernández, M. Carrillo, and F. Rodríguez; (second row) assistant manager J. López, J. Monges, T. Tirado, A. Alfaro, F. Navarro, R. Cabrera, John Monges, A. Gonzáles, and umpire A. Hernández. (Courtesy of Félix Ulloa.)

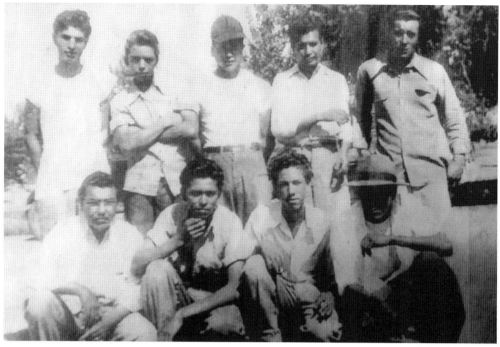

The Bear Creek Wolfs baseball team took to the baseball diamonds in Planada and Merced many times during the 1940s. The members of the team lived at Bear Creek labor camp. From left to right are (first row) Lico Romero, Manuel García, Mere García, and Pete Cónsul Ramírez; (second row) Conrad "Blackie" Gloria, Ray Banda, Chito Franco, and Ernie Fierro. (Courtesy of Conrad "Blackie" Gloria.)

Brothers Peter (left) and Al Moreno were excellent players during the 1940s and 1950s in Tracy, California. Peter pitched, and Al played first base. In the early 1950s, Al and three of his brothers were called into military service during the Korean War. Al was a member of the Marine Corps. He drove a truck supplying troops on the front lines and often came under heavy bombardment as the enemy aimed deadly fire on the convoy. After the war, he played and umpired for many years. (Courtesy of Al Moreno.)

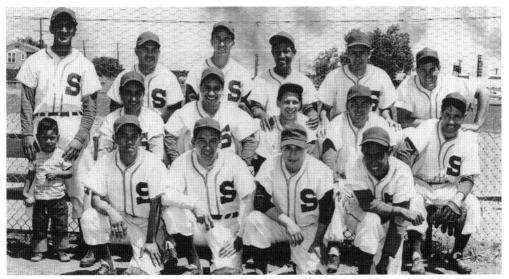

The 1952 Stockton team was formed prior to the Cal-Mex League, which included several teams from the Central Valley of California. Roy Álvarez Jr. (second row, third from left) and his father, Roy (first row, second from left), played on the same teams for 12 years. On Father's Day, June 20, 1976, the fans presented the elder Roy a plaque for 31 years entertaining fans with his incredible play on the diamond. Roy Jr. continued to play and manage for several more years. He still has two baseball scrapbooks of his father. (Courtesy of Roy Álvarez Jr.)

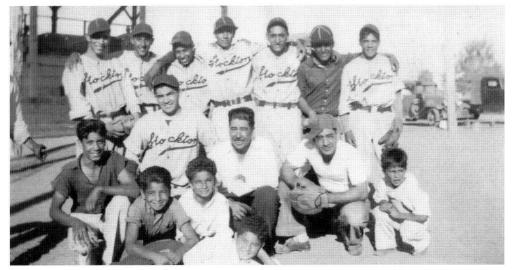

This photograph was taken in 1937 at Stribley Park in Stockton. This all-Mexican team was comprised of fathers, uncles, sons, and nephews. From left to right are (first row) Manuel Ávila, Bill, Moses, and Robert Valverde; (second row) Manuel Valverde; (third row) Ralph, Jesús "Sue," and Ralph Valverde Jr.; Manuel Gardea; Mike Islas; Lalo Guerrero; and Fred Ávila. The batboys are unidentified. In 1973, the Stockton Hall of Fame honored the five Valverde brothers, Ralph, Joe, Jesús "Sue," Manuel, and Tino. They raised 81 outstanding athletes across multiple generations. (Courtesy of Louis A. Valverde.)

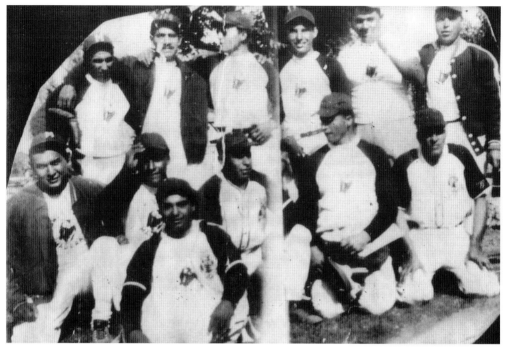

The 1953 Madera Owls were an outstanding softball team. From left to right are (first row) Martín Medellín, Victor Romo, Frank Montana, Mike Abundis, Frank Molina, and Henry Soto; (second row) Frank Atilano, Sal Rodríguez, Alec Molina, Eddie Chapa, an unidentified fan, and Tony Arroyo. (Courtesy of Eddie Chapa.)

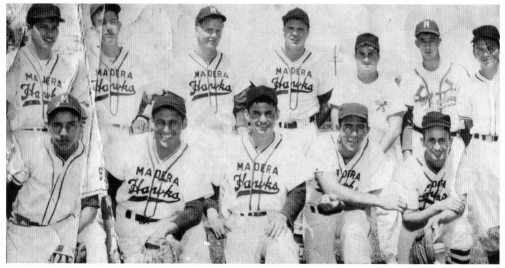

The Madera Hawks were a powerhouse team in the Central Valley. From left to right are (first row) Jim Arballo, Oscar and Eddie Chapa, and Phillip and Rex Queen; (second row) Tom Solorio, Larry Nolen, Bob Thomas, Larry Pearson, Dave Hancock, Tony Molina, and John Brown. Larry Pearson's father, Monte, played for the New York Yankees. (Courtesy of Eddie Chapa.)

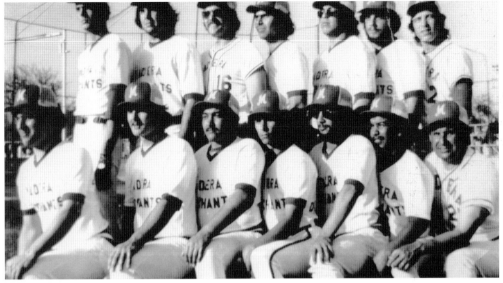

This is the Madera Merchants team during the 1970s. From left to right are (first row) John Chapa, Marty Cargill, Oscar Olguín, Louie López, Steve Botoni, Stan Roque, and Eddie Chapa; (second row) Ray Wright, Bob Gretz, Tony Fields, Dale Voyles, Sal Aguayo, Mickey Gutknecht, and David Davis. (Courtesy of Eddie Chapa.)

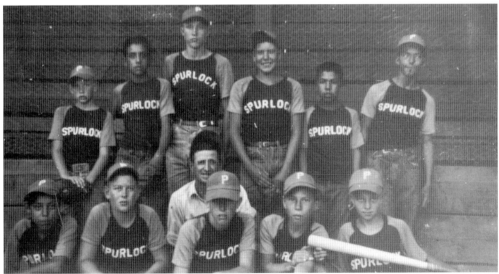

This photograph was taken in 1949 in Planada, California, near Merced. John Chávez is second from left in the second row without a cap. This was the first team he ever played on, a Pee Wee team sponsored by Spurlock Lumber Yard. Chávez would have an outstanding baseball career in high school, college, the military, and professionally. He wore glasses, but they were broken, and he could not see until the lights went on. He was a catcher. His pitcher was Guadalupe Sánchez (second row, far right). Other players included Rudy Rodríguez (to the left of Guadalupe) and Tony Guerrero (first row, far left). Most of the players were 13 years old and small, but they could compete with the larger white teams. (Courtesy of John Chávez.)

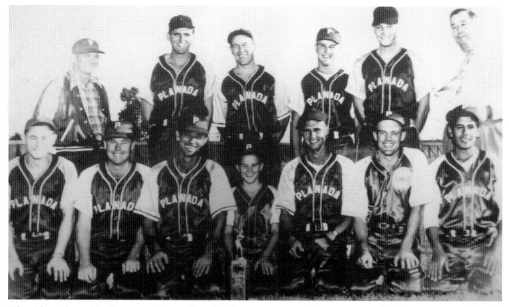

The Planada softball team, pictured in 1948, was a top-caliber team in the late 1940s and early 1950s. This particular team won the Valley softball championship. Walter Mitchell was the star pitcher for 10 years. The lone Mexican American on this team was 16-year-old Joe Trujillo (first row, far right), who played shortstop. In high school, Trujillo was a star pitcher at Merced High, and played a lot of semiprofessional baseball in Merced County and throughout the Central Valley. (Courtesy of John Chávez.)

Pictured here is 13-year-old John Joséph Chávez (left) with his father, John Chávez, in Planada, California. Both were preparing for games on the same day. John Sr. coached his son in Little League, Pony League, and with the Latin American Club, a semi-professional traveling team. John Jr. played four years of baseball and football at Le Grand High School. He was encouraged to learn to play all the positions by his dad. He mostly pitched, caught, and played outfield. He is now 50 years old and a teacher at Valley High School, a continuation school. All his children (Venessa, Ernie, Capri, and Erika) were outstanding athletes. Two of his daughters were star basketball players at Modesto Community College. John Sr. was an outstanding player in college and in the military. He played many years on softball teams throughout the Central Valley. (Courtesy of John Chávez.)

THE MERCED REGION

SANTA MONICA

Santa Monica is a beachfront city in western Los Angeles County, bordered by the Pacific Ocean on the west, West Los Angeles on the east, Pacific Palisades to the north, and Venice to the south. Santa Monica was named after the Christian Saint Monica. In the 1870s, the Los Angeles & Independence Railroad Company connected Santa Monica with Los Angeles, increasing the number of visitors to the area and encouraging development of tourism, ultimately leading to increased population as visitors opted to remain. In addition, Santa Monica's close proximity to Los Angeles International Airport (less than eight miles) made Santa Monica a destination for vacationers seeking beachside exposure.

With an ever-growing population, both commercial and recreational activities expanded. Douglas Aircraft Company (1922), the Rand Corporation (1945), and PaperMate (1957) were three of the city's major employers. Mexicans, however, were primarily gardeners and landscapers or worked at the local nurseries. The famed Santa Monica Pier was built in 1909, followed by Pacific Ocean Amusement Park, a wildly popular entertainment center. During the early 1900s, Mexican immigration accelerated due to a poor Mexican economy and civil strife. Many Mexicans traveled north seeking employment and reconnection to family members. People of color were allowed to own or rent property only within certain boundaries of the city. Mexican Americans settled between Pico and Santa Monica Boulevards from Twelfth Street up to Centinela Avenue, commonly known as the Pico District.

Along Olympic Boulevard, from Fourteenth Street to Twentieth Street, Mexican businesses thrived in the form of restaurants, bars, and tortillerias. Many of these businesses sponsored Mexican baseball teams in Santa Monica. The Mexican community became fragmented in 1961, when it was decided by the city that the Santa Monica Freeway should run through the middle of their already small community. Many Mexican families were displaced by the encroaching freeway and were forced to relocate to outlying communities. St. Anne's Church and School were significant institutions for Mexicans in the area, serving as a center for all activities. For Mexicans, love of baseball developed at St. Anne's School through the Catholic Youth Organization (CYO), where baseball competitions took place between Catholic schools throughout the Los Angeles Archdiocese.

Life for Mexican Americans in Santa Monica centered around St. Anne's Catholic Church, an annex of St. Monica's Catholic Church. The Serra, Guajardo, Rivera, Ramos, and Romo families all went to St. Anne's School at one time or another. Many families sent generations of children to the school. There they developed their love of baseball playing in the CYO leagues. Pictured is Raymond Serra's eighth-grade graduation from St. Anne's Catholic School in 1932. Ray is in the second row, second from right. (Courtesy of Frank Ramos.)

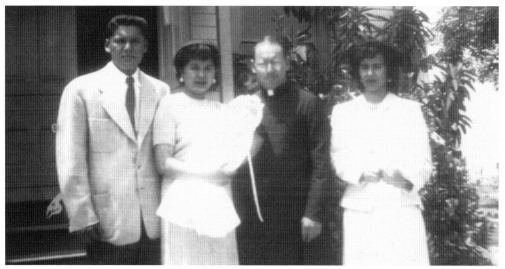

In 1951, when St. Anne's became a parish church, tradition continued, as children of the early ballplayers also attended St. Anne's School. Ray Serra's three children, Manuel, Ray Jr., and Alicia Serra, are St. Anne's alumni. Alicia Serra Stevens was the first baby baptized in the newly recognized parish in July 1951. She is pictured here with her godfather and uncle Ismael Gálvan (Ray's brother), godmother and aunt Irene Gálvan (Ray's sister), Monsignor Cyril J. Wood, and her mother, Evangeline Martínez, all of whom attended St. Anne's School. (Courtesy of the Serra family.)

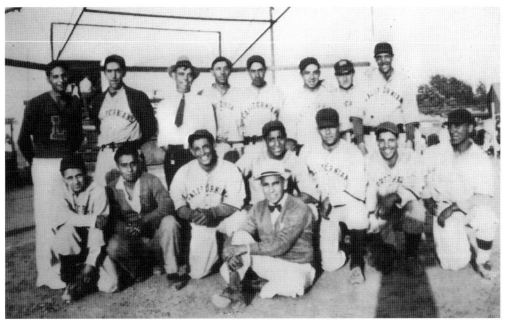

The 1935 Californian team is mostly unidentified, with the exception of Ray Serra (first row, third from right). Serra's family emigrated from Guadalajara, Mexico, to Juárez, then to Kansas, prior to arriving in Santa Monica, where Ray enrolled in kindergarten. Employed as a ditch digger in Pacific Palisades, Ray's father, Guadalupe Serra, was buried alive at 33 when Ray was eight years old. Ray's mother, Alejandra, lived to 103. (Courtesy of the Serra family.)

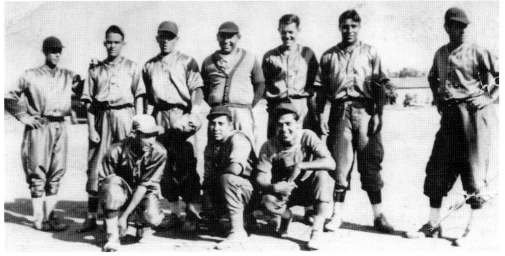

This 1938 team with unmarked uniforms is believed to have been sponsored by Cycle and Sport Shop. The team played together for several years. Many of the players remain unidentified, with the exception of Ángel Guajardo (first row, third from left) and Ray Serra (second row, far right). According to the Santa Monica Evening Outlook, the Cycle and Sport Shop lineup included Carmen Casillas, Ray Serra, Ángel Guajardo, Félix Guajardo, Alex Casillas, Pete Osti, Mario Vásquez, Valentine Lugo, and Talo Mireles. (Courtesy of the Serra family.)

This Cycle and Sports Shop batter is Ray Serra in 1938. Serra played shortstop and first base. While covering the bag at third, a runner slid into his leg, fracturing it. A New York Yankee scout, interested in Serra, cancelled a scheduled meeting with him, fearing he could no longer play at a professional level, thus ending his chances of being drafted into the minor leagues for the Yankees. This injury didn't dampen his indomitable spirit, as he continued to play recreational ball. (Courtesy of the Serra family.)

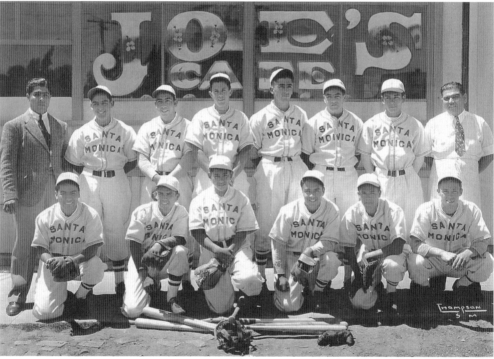

The Santa Monica Cafemen, sponsored by Joe's Café on Fourteenth Street and Olympic Boulevard, includes, from left to right, (first row) Mario Vásquez, Ray Serra, Joe's Café owner's son and batboy Rubén Bontty, unidentified, Carmen Casillas, and Bud Boyce; (second row) manager and Joe's Café owner Sam Bontty, Ángel Guajardo, Vally Rivera, Pete Osti, Valentine Lugo, Talo Mireles, Ralph Hernández, and cook Joe Bontty. At the end of the season, the Cafemen took second place in the city championship. (Courtesy of the Serra family.)

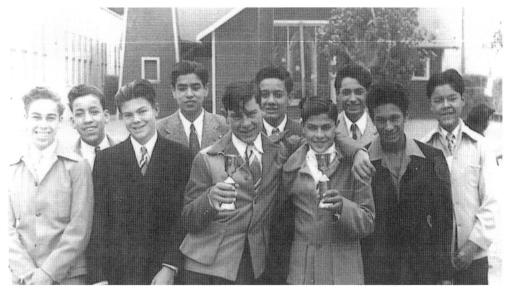

St. Anne's School sponsored baseball teams through the CYO, competing against other Catholic schools in the Los Angeles Archdiocese. This late 1930s team appears to have won the league. From left to right are (first row) Lupe Gómez, Larry Bourget, Frank Talamontes, Sammy Romo, and Frank Badilla; (second row) Ernie Maderino, Ernest Mireles, two unidentified, and Joe Macías. The building behind the players is the original St. Anne's Church, built in 1908 by its parishioners. (Courtesy of Ray Romo.)

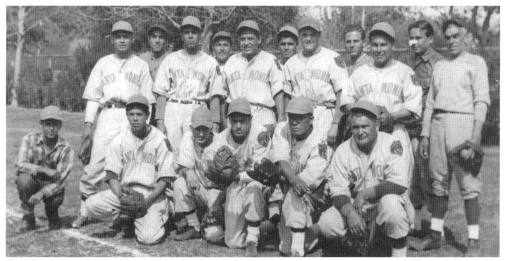

This early 1940s Santa Monica team includes, from left to right, (first row) Elias Casillas, Manuel Serra, Larry Alcala, Sammy Romo, Ray Serra, and Art Lamorie; (second row) Willie Hernández, unidentified, Ángel Guajardo, Goy Casillas, Mario Vásquez, and Manuel Vega; (third row) Benny Tapia, two unidentified, Gus Mondine, and Félix Guajardo (with a broken nose). Santa Monica teams tended to play together for years. Seldom was there an opening on these teams, as family members tended to occupy several positions. Two sets of brothers played on this team: Ray and Manuel Serra and Ángel and Félix Guajardo. (Courtesy of Ray Romo.)

Manuel Serra (right) and Ángel Guajardo (left) of the Santa Monica team are seen here in the early 1940s. Manuel often played catcher for Ángel's pitching. Manuel was known to have said he could play catcher sitting in a rocking chair, as Ángel's pitching was pinpoint accurate. For several years, Manuel and Ángel were consistently paired in their respective positions. Baseball in Santa Monica took place at Municipal Park, located on Fourteenth Street and Olympic Boulevard, adjacent to the Mexican-owned businesses along the boulevard. Mexican businesses along Olympic Boulevard, such as the Gallegos Tortilleria, sponsored many teams. Today, the majority of these businesses are gone. The baseball field remains active, though it is now referred to as Memorial Park. Equipped with stadium lights, recreational night games continue. (Courtesy of Serra family.)

St. Anne's students won many CYO championships. These 1943 archdiocesan softball champs are, from left to right, (first row) ? Morales, Sandy Arenas, Ángel Gasca, Freddy Gallegos (holding trophy), Joe Gasca, and Vince García; (second row) Ralph Orozco, three unidentified, and Henry Ángel; (third row) Frank Ramos, Ángel Rangel, Father Grimes, and Peter Guerrero. St. Anne's families were financially challenged. Actors June Haver and her husband, Fred McMurray, sponsored Christmas parties for the students, where each child was fed, entertained, and received a gift. (Courtesy of Frank Ramos.)

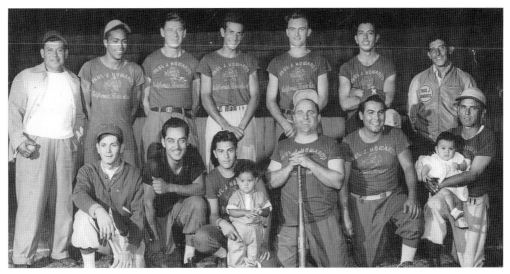

The 1947 Flowermen were sponsored by Paul J. Howard Nursery. From left to right are (first row) Ralph Hernández, Ángel Guajardo, Sammy Romo holding son Ray Romo, Davey Robertson, Mario Vásquez, and Ray Serra holding son Manuel Serra; (second row) manager Fred Rivera, Frank Ramos, John Pakes, Frank Casillas, Rudy Pakes, Manuel Serra, and Lewis Leyvas. Baseball was a way of life, with children socializing at the field while their fathers played. Ray Serra met his future wife, Evangeline, when both were employed by the nursery in 1946. (Courtesy of the Serra family.)

Two-year-old Raymond Romo emulated his dad Sammy from an early age. Raymond played baseball as a youth with Ray Serra's son Manuel on a travel team. Raymond went on to coach varsity baseball at both Venice High School and St. Monica's Catholic High School, where he coached first baseman Carlos Casillas and his brother Oscar, who both later attended the University of Southern California and were on the 1998 NCAA Division I team that won the College World Series. In 1995, Carlos was drafted into the minor leagues by the Baltimore Orioles. Dr. Oscar Casillas is vice president of the board for North Venice Little League and a volunteer assistant coach for high school varsity baseball. (Courtesy of Ray Romo.)

This 1959 photograph shows Ray Serra's son Manuel, a St. Anne's alumnus. Off the field, Ray was relentless in having both sons practice on Twenty-Second Street, where they lived. Here Manuel is practicing his bunt. After having grown up on the field as his dad played, he too developed a passion for baseball. As a youth, he played Olympic Little League. Upon completion of his military obligation, Manuel played fast pitch softball in the B League, where teams were selected by the coaches to provide a higher level of competitive play. Manuel and Ray Jr. played organized ball with the Romo, Guajardo, and Vásquez children. (Courtesy of the Serra family.)

Another St. Anne's alumnus, Ray Serra Jr., is shown here in 1961. Like his older brother, Manuel, he played B League baseball at Silva Field, now Exposition Park. Ray Jr. coached his daughters, Bernadette and Jessi Rae, at Culver City High School. Ray Jr., along with his brother Danny, managed and played on a men's softball team, the Wild Bunch, for several years. Despite an overall population of nearly 90,000 people in Santa Monica, Mexicans chose to socialize and congregate amongst themselves. Thus the children of the older ball players played ball together as their dads had done. (Courtesy of the Serra family.)

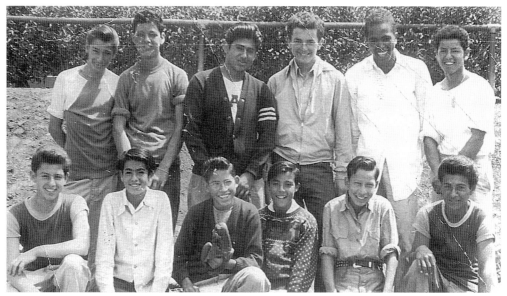

St. Anne's won another CYO trophy in 1948. From left to right are (first row) Luis Romo, Manuel Morales, Phillip De La Torre, David Arumbla, Natie Quiroz, and Casey Romero; (second row) Alfred Romo, Benjie Guajardo, Charlie Boroso, Pete Casillas, Frank Ramos, and Henry Casio. Monsignor Cyril J. Wood served as pastor of St. Anne's Church from 1951, when it was first established as a parish, until his death in 1987 at age 74. (Courtesy of Frank Ramos.)

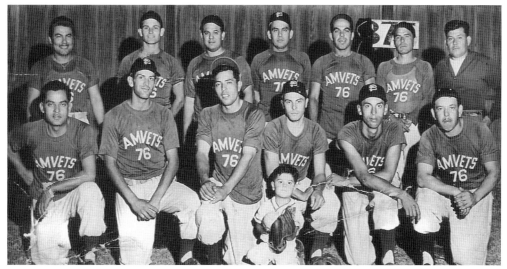

The 1949 Santa Monica AMVETS team included, from left to right, (first row) Ángel Guajardo, Frank Casillas, Manuel Serra, Sammy Romo with son Raymond Romo in front, Socorro Casillas, and Rufino Hernández; (second row) Mario Vásquez, Larry Baez, Carmen Casillas, Félix Guajardo, Vince Mutaw, Ray Serra, and manager Fred Rivera. The 375 marking on the back fence at Memorial Park indicates 375 feet, the size of a major-league ballpark. The AMVETS completed the 1949 season as "*the* team" in the Santa Monica Softball A League, with a perfect record of 23 wins. (Courtesy of the Serra family.)

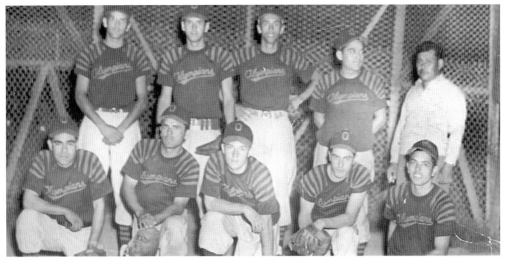

The 1950 Olympic Merchants (Olympians) won 22 of their 24 games. From left to right are (first row) Mattie Velásquez, Ray Serra, Larry Alcala, Sammy Romo, and Manuel Serra; (second row) Frank Casillas, Rudy Pakas, Socorro Casillas, Ángel Guajardo, and manager Fred Rivera. It is believed that the Olympic Merchants were sponsored by some of the Mexican merchants along Olympic Boulevard, including Casillas Market, Tienda Martínez, and Joe's Café. Merchants were able to promote their businesses and share in civic pride by sponsoring baseball teams. (Courtesy of the Serra family.)

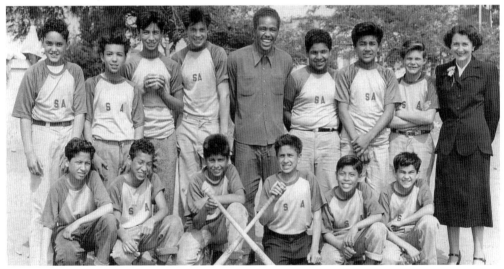

The CYO softball champions of 1950, St. Anne's, were coached by Frank Ramos. From left to right are (first row) Frank Quiroz, Victor Aguilar, Joe Romo, Alfonso Rodríguez, José Verduzco, and Joe Casillas; (second row) David Escarcega, Art Gaxiola, Ángel Hernández, Leonard Bourget, coach Frank Ramos, Leonard Valenzuela, Robert Porras, Johnny Bourget, and teacher ? Powell. As his days of playing adult ball wound down, this period showcased the introduction to Frank Ramos's coaching career. Frank received a commendation from the City of Santa Monica for his many years of service. (Courtesy of José Verduzco.)

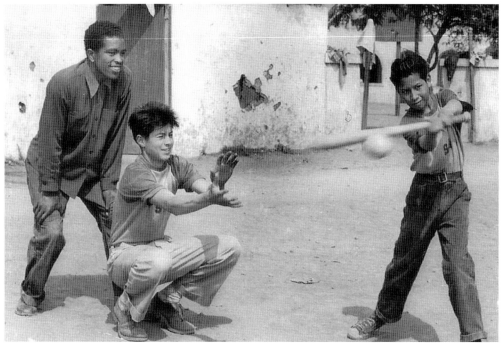

St. Anne's holds batting practice in the 1950s. Notice that the catcher has no glove. St. Anne's Mexican student population came primarily from families that could barely afford necessities for everyday life, much less the frills of athletic equipment. St. Anne's, with so many tuition-free students, did not always have the resources for equipment. From left to right are umpire Frank Ramos, catcher Leonard Bourget, and batter Frank Quiroz. Coach Ramos dedicated over 70 years to the St. Anne's athletic program after graduating and serving his country in the Army. (Courtesy of José Verduzco.)

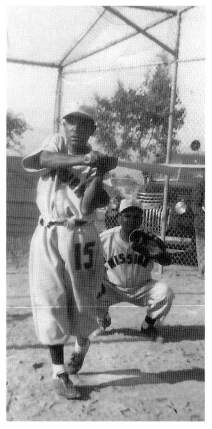

Playing with a 1952 semipro San Fernando Mission team, Ray Serra swings at a ball. According to Ray's son Manuel, Ray played on different teams three times a week and on Sundays. Ray was known to have played on teams named Azteca, Californians, Cafemen, Flowermen, Olympic Merchants, Santa Monica, Garfield, Cycle and Sports, AMVETS, San Fernando Mission, ESA Caballeros, and several All-Star teams. Once he stopped playing ball, he umpired at Memorial Field, the same field where he had played most of his games. (Courtesy of the Serra family.)

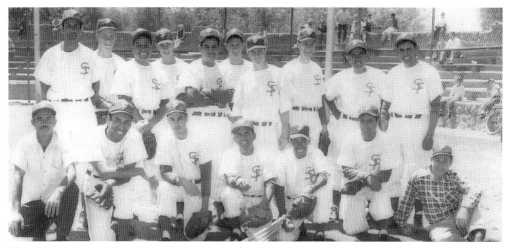

The 1952 semi-pro San Fernando Missions Baseball team included five Santa Monica players. From left to right are (first row) manager Pete Acebo, Socorro Casillas (Santa Monica), Sammy Romo (Santa Monica), Ray Serra (Santa Monica), and three unidentified; (second row) Frank Casillas (Santa Monica), three unidentified, Ángel Guajardo (Santa Monica), and San Fernando Valley player Nick Salas; (third row) all unidentified. Having no freeway, these Santa Monica ballplayers faced an arduous commute as they traveled to and from the valley. (Courtesy of Frank Casillas.)

Although many teams were predominantly Mexican, there were teams that were more diverse, such as this 1957 Venice Little League team. From left to right are (first row) Richard Holguin, Ronny Okomoto, unidentified, Chick Reseda, and unidentified; (second row) Bernard Orozco, Ray Romo, Mickey McDonald, unidentified, and Bobby Parker: (third row) ? Monjolly, unidentified, Brook Hurst, Tommy Hurst, Louie Rivera, and Mitchell Parker; (fourth row) two unidentified and manager ? MacDowell. (Courtesy of Ray Romo.)

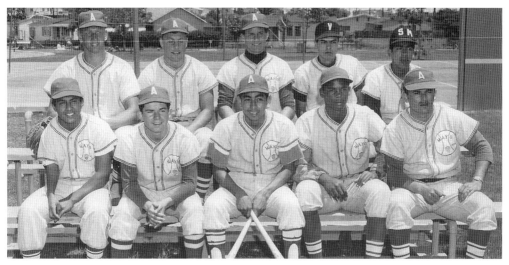

Marine Park in Santa Monica was host to an independent baseball league in 1963. From left to right are (first row) Tommy Sánchez, Steven Parra, Gilbert Carranza, Tony Macneil, and manager Johnny Soto; (second row) Bob Klein, unidentified, Rupert Casillas, Ray Romo, and Joe Esparza. Carranza, Romo, and Esparza were all St. Anne's students. Joe Esparza later lost his life in combat during the Vietnam War. His name is engraved on a memorial wall at Santa Monica's Woodlawn Cemetery. (Courtesy of Ray Romo.)

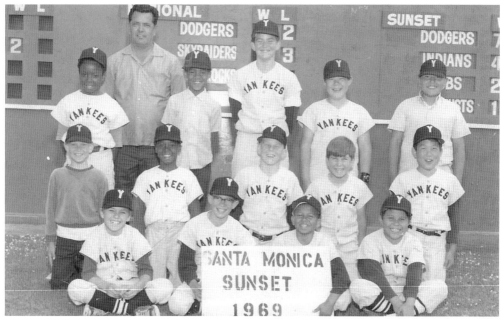

Manuel Serra, formerly a St. Anne's student and recreational baseball player, became a coach after his playing years, sharing his expertise and time with this Santa Monica Sunset team in 1969. The only player identified is Richie Gutierrez (first row, far right), a St. Anne's student. Many former players became coaches and umpires when no longer physically able to play. (Courtesy of the Serra family.)

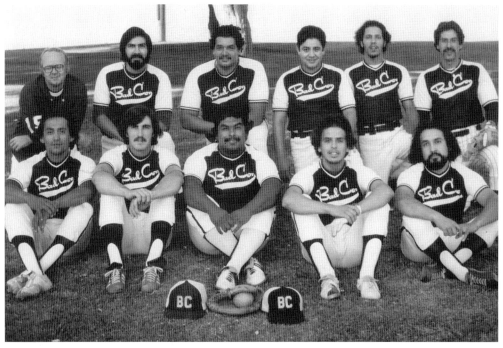

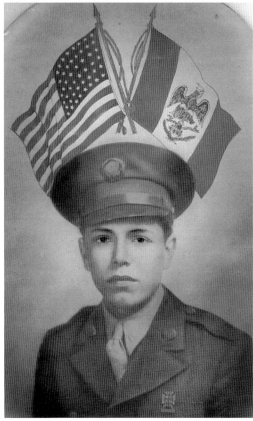

This young adult Santa Monica team of the 1970s, Bad Company, included four former St. Anne's students (Gálvan, Gómez, and both Botellos). From left to right are (first row) Larry Cruz, Alan Forsythe, Tommy Botello, Aurelio Carlos, and Tommy Gómez; (second row) Jerry Scobee, Larry Vásquez, Frank Botello, Tommy García, Ronny Vincent, and Rubén Gálvan. (Courtesy of Frank Botello.)

The outbreak of World War II impacted Santa Monica baseball. Manuel Serra enlisted in the Army and trained at Fort Bragg, North Carolina, in radio communications. Ray Serra, eager to be with his brother and serve his country, packed his bag, said his goodbyes, and proceeded to the recruitment center. Upon hearing that he couldn't enlist due to his previous leg injury, he cried. Ray never did serve in the military, but he was recruited by the Navy to play ball and played with future hall-of-famer Bob Lemon. (Courtesy of Michael Serra.)

Ángel Guajardo served in the US Army during World War II and was deployed to the Philippine Islands, where he played and managed Army baseball teams. A memorial to the various wars has been erected at Santa Monica's Woodlawn Cemetery noting those who died in combat. Among those listed are Medal of Honor recipient Joe Gandara, Jesus Sainz Barrona, Salvador Guajardo (Ángel's brother), John Ruiz, Justino Diaz, Louis B. Segura, and Nicholas Villa (World War II); Antonio Hernández (Ray Serra's cousin) and Santos Livas (Korean War); and Frank Holguin and Joe Esparza (Vietnam War). (Courtesy of Art Guajardo.)

Frank Casillas, another ball player, also enlisted and served honorably in Japan as part of the Army's quartermaster corps. This photograph was taken in Sendai, Japan, in 1951. Frank continued playing baseball in the Army on the 40th Infantry team, earning the softball championship trophy after defeating a military police team. Upon discharge, Frank resumed playing with the San Fernando Missions semi-pro team for about six years and with recreational Santa Monica teams. Because few people had televisions in the 1940s, baseball stands were often filled to capacity by families and fans, with the overflow standing alongside the bleachers. (Courtesy of Frank Casillas.)

During the Vietnam War, Ray Serra was able to boast about his son Manuel A. Serra, who honorably served in the Army. Manuel earned two Purple Hearts after being wounded in battle twice. Manuel served with the 82nd Airborne during Vietnam. He attended basic training at Fort Ord, California, and received additional training at Fort Bragg, North Carolina. After coming back to the United States in 1967, Serra was deployed by the Army to assist with the Detroit riots. His dad, Ray, reported that in the 1930s and 1940s, every block in the Mexican neighborhoods of Santa Monica had informal baseball teams that competed daily against one another. (Courtesy of the Serra family.)

Santa Monica–born Rick Prieto (left) moved to Culver City in 1969. Prieto played baseball for Culver City High School and in college before he signed his first professional contract with the Rojos de Caborca in Sonora, Mexico. In Mexico, he earned the league batting title and set the record for doubles. One of his highlights is meeting Fernando Valenzuela (right). As of 2016, Prieto is head baseball coach at Culver City High School, where he has been recognized as Ocean League Coach of the Year in 1999, 2006, 2010, 2012, and 2016. (Courtesy of Rick Prieto.)

SAN DIEGO

San Diego County is located in the most southern part of California. It is bordered by mountains and desert in the east, the ocean on the west, Los Angeles on the north, and Mexico to the south. The proximity to Mexico has had a great influence on San Diego as a whole and baseball in particular. Players often played for teams on both sides of the border or at least against teams from each side. Today, the lines to cross back from Tijuana, Mexico, can take up to four hours. In the early days, a small inspection station with very little scrutiny of those crossing to and from Mexico was the only obstacle to coming to San Diego. The ease of crossing made it natural to cross back and forth to play and watch baseball.

San Diego also had the distinction of being the only border city in the United States that had a settlement house, in the midst of the local Logan Heights neighborhood. In the late 1800s and the early 1900s, settlement houses were established to Americanize the foreign-born. In San Diego, the settlement house was named Neighborhood House and provided a variety of services to the families in the surrounding area. Between the 1920s and 1950, the Neighborhood House team was often viewed as a semipro team. The Neighborhood House team was playing against the Navy team on December 7, 1941, when Pearl Harbor was hit and the Navy team had to forfeit the game.

Early newspaper articles portrayed the boys in the area as not following the rules of baseball. The same articles refer to the boys as "hard core." The reality is that like boys across the country, regardless of their ethnic background, they made up their own rules. This is not unusual in any community and certainly applied to the Logan Heights boys.

Baseball gave the boys tremendous opportunities but also exposed them to additional discrimination. Several of the men the authors interviewed remembered teams forfeiting their game rather than playing against a "Mexican" team.

In the early 1920s, the Neighborhood House team was coached by Bill Breitenstein, who is credited with bringing baseball to Logan Heights. Baseball was part of the boys' lives before Coach Breitenstein, but not with formal rules. A little-known fact is that the best-known Mexican American player from San Diego was Ted Williams, whose mother was Mexican.

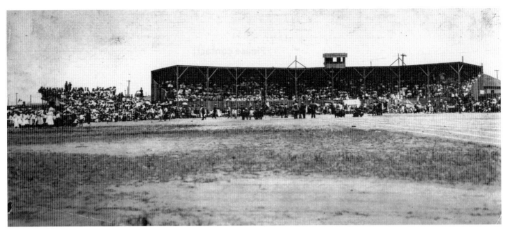

This is the Logan Heights baseball field in 1909. Later, the name was changed to Athletic Park. Baseball and softball were played in various locations in Logan Heights, including Memorial Junior High, the Neighborhood House field, Golden Hill Park, and Morley Field. This was before Interstate 5 and the Coronado Bridge dismantled a once-united Mexican American community. (Courtesy of Maria García.)

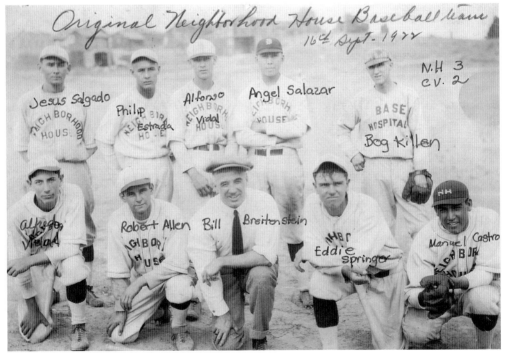

This is the original 1922 Neighborhood House baseball team. In keeping with the focus of "Americanizing" the Mexican American community, the boys were known as the Veterans to honor World War I soldiers. This particular game was played at the field at Chollas View in Logan Heights. Neighborhood House won the game 3-2. From left to right are (first row) Alfredo Vidal, Robert Allen, coach Bill Breitenstein, Eddie Springer, and Manuel Castro; (second row) Jesús Salgado, Philip Estrada, Alfonso Vidal, Ángel Salazar, and Bog Kilen. (Courtesy of Dave Young.)

This June 1924 newspaper article chronicles the changes coach Bill Breitenstein brought to the boys from Neighborhood House, also seen in many other articles. The articles contend that the boys played by their own rules and were "tough and quarrelsome." The fact is, like young boys everywhere, they probably made their own rules and did argue among themselves about the various calls. (Courtesy of Maria García and Save Our Heritage Organisation [SOHO] Collection.)

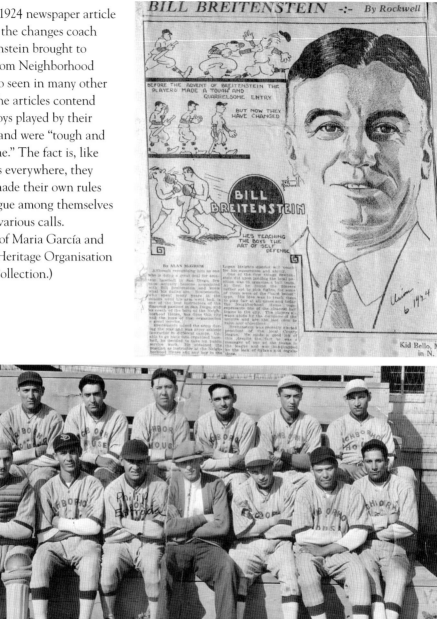

This 1931 photograph appears to show the Neighborhood House team playing at Memorial Junior High School. Philip Estrada is third from left in the first row. Carmen Castillo is third from right in the first row. Castillo, like many of the other boys from Logan Heights, swam across the bay to Coronado. Many of the men interviewed recalled crossing the bay to steal fruit from the trees in Coronado. (Courtesy of Maria García and SOHO Collection.)

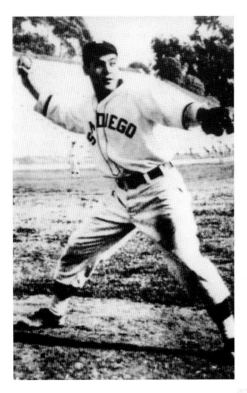

This picture was taken when John Bareño was 17 years old. While at San Diego High School, Bareño was told by his coach he would receive a scholarship to the University of California at Berkeley. However, the school year ended without the promised scholarship. He then decided to play in the Negro Leagues for two reasons: because they accepted Mexican Americans and the league paid well. Bareño served in World War II and returned to San Diego, taking advantage of the GI Bill to pay for barber school. At the age of 42, he went to college and earned bachelor's, master's, and doctorate degrees. He passed away in 2015. Until he died, Bareño still remembered taking the long walk from Logan Heights to the pool at Mission Beach and then being turned away because he had brown eyes. He had to wait several hours for his blue-eyed friends to come out of the pool before making the long walk back to his neighborhood. (Courtesy of John Bareño.)

Alfredo Vidal played center field for the Neighborhood House in the 1920s. Like many of the other players at the time, he played for multiple teams, such as the Foreign Club in Tijuana, Mexico, Ortiz Chevrolet, and C.J. Hendry Company. This photograph shows him in his Navy base hospital team uniform. He worked as a civilian employee at the North Island Naval Base. Alfredo lived on South Evans Street for many years. He had received a letter from the Hollywood Stars to report to spring training but did not report. Instead, he married Virginia Savin, and they had four children. His brother-in-law Henry "Peanut" Savin played for the San Diego Padres in 1945. Alfredo died in 1968. (Courtesy of Dave Young.)

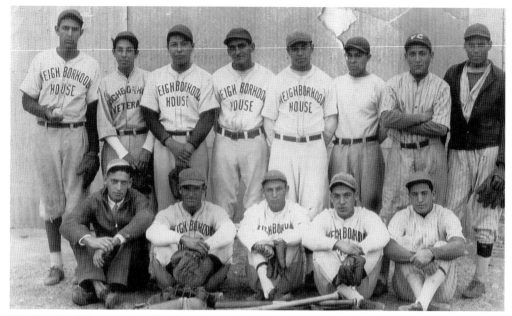

The family of Carmen Castillo (first row, far right) left Mexico to escape the revolution. He played baseball at the Neighborhood House and San Diego High School. He was very proud that he hit a home run off Ted Williams when Williams was playing for Hoover High School. Castillo helped San Diego High School win the 1939 state championship. He managed the Neighborhood House team until he was called to serve in World War II. Also seen in this 1939 photograph is José Ortega Sr., standing in the back row, wearing a black sweater. (Courtesy of Maria García and SOHO Collection)

Joe "Babe" Ceseña was born in 1915. He was called "Babe" because it was understood he was every bit as good as Babe Ruth. It is believed that he had a contract with the Brooklyn Dodgers. His friends and family purchased baseball equipment for him. Unfortunately, the equipment was stolen when he arrived at spring training. Even more devastating, the Dodgers turned him away when they realized he was Mexican American. He was told to return to San Diego. Ceseña is best known for throwing runners out while on his knees. He passed away on February 5, 1973. (Courtesy of Billy and Tenie Ceseña.)

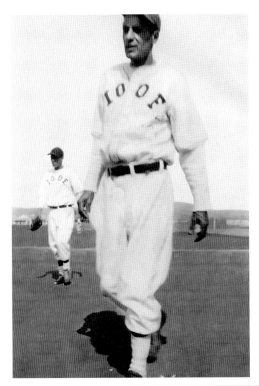

Joe Trejo was born in Carlsbad, California, in 1916. He played baseball for Oceanside High School, north of San Diego near Camp Pendleton Marine Base. He also played for the International Organization of Odd Fellows. When Trejo was selected to the all-star team, he played against Ted Williams. While serving in the Army, he married Tulie Piña from Logan Heights. Tulie became well known for her baking ability and won the Pillsbury bakeoff on nine separate occasions. Trejo passed away at 98. (Courtesy of Sally Ramírez.)

A celebration for winning the championship was held at the Aztec Brewing Company, located at 2301 Main Street in the 1940s. Aztec Brewing came from Mexicali, Mexico, in 1933 and closed its doors in 1953. The murals on its wall are now on display at the Logan Heights Library. (Courtesy of the Logan Heights Historical Society.)

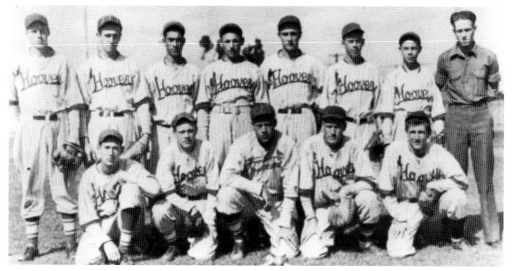

Ted Williams (first row, far left) played baseball at Herbert Hoover High School. He also played for Cramer's Bakery and the Memorial playground baseball team, both located in Logan Heights. He once played against a Navy team from the USS *Omaha*. He was signed by the Padres of the Pacific Coast League. His big break was being recruited by the Boston Red Sox, where he spent his entire career. Williams was inducted into the Baseball Hall of Fame in 1966. He passed away in 2002. (Courtesy of Maria García.)

Ted Williams is considered one of the best baseball players of all time. He is the last player to hit over .400, doing so in 1941. Most people are not aware that on his mother's side, Ted Williams was Mexican. His mother, Micaela May Venzor, who was from El Paso, Texas, worked for the Salvation Army. A great deal of her work took place in Tijuana, Mexico. She was an evangelist and was known as the "Angel of Tijuana" because of her charity work. Ted grew up on Utah Street in the North Park area of San Diego, where there is a ball park named in his honor. (Courtesy of Maria García.)

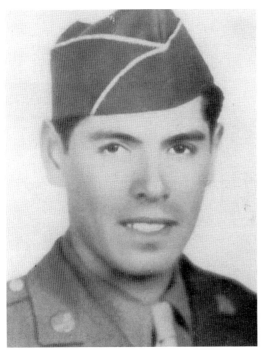

Manuel "Nay" Hernández was the only member of the Pacific Coast League Padres to be killed in World War II. He was one of 15 children. Hernández started his baseball career at Neighborhood House and played for San Diego High School, where he won the state championship. He was not drafted because he had a heart murmur, but later it was determined that if he was healthy enough to play baseball, he was healthy enough to be drafted. Hernández had a premonition that he would not return to San Diego alive from the war. (Courtesy of Maria García.)

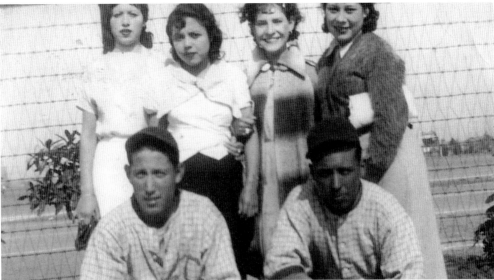

Sisters Alberta (second row, left) and Lydia Millan (second row, right) are seen here with their brothers Tony (left) and Tino (right). The Millan family has a long and rich history of baseball throughout Logan Heights. The sisters were scorekeepers for the Old Town Merchants and for Cramer's Bakery. On this team, Tony pitched and played the outfield and Tino played shortstop and the outfield. Their father, Sam, coached the Old Town Merchants and Cramer's Bakery. In 1934, Tony pitched a no-hit game when he played for the Memorial Nine team. The team was comprised mainly of players who had graduated from Memorial Junior High School. (Courtesy of Tony Millan Jr.)

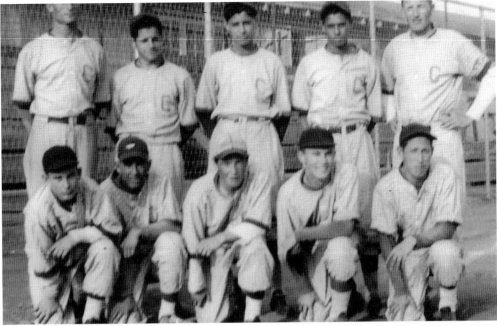

The 1930s Cramer's Bakery team had outstanding hitters, great pitching, and speed running the bases and catching flyballs in the outfield. Players included Sam Millan (first row, second from left), Tino Millan (first row, far right), and Manuel "Nay" Hernández (second row, second from right). Sam and Tino were father and son. Coach Powell is in the second row at far right. A decorated World War II veteran, Johnny ?, who played for the Toltec Midgets, remembers that the Neighborhood House teams could not even afford to purchase baseballs, so they had to wash the old ones, or, if they were lucky, the opposing teams gave them baseballs. (Courtesy of Tony Millan Jr.)

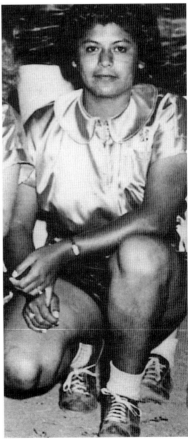

In the late 1930s, Valentina "Tina" Hernández's mother objected to her playing baseball, whereas her brothers and her father were supportive. Manuel "Nay" Hernández was one of her brothers. Her mother, Gregoria Hernández, commented: "*béisbol no es para las mujeres, necesitas aprender a hacer tortillas.*" (Baseball is not for women; you need to learn how to make tortillas.) One of her favorite memories is of a game played on a reservation in Arizona against Native Americans. After the game, Native Americans asked for autographs. She remembered signing autographs until it was time to get on the bus. (Courtesy of Bill Swank.)

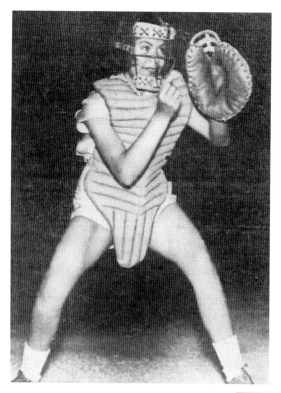

Valentina "Tina" Hernández takes great pride in her baseball skills, boasting that she was "the best catcher in California." Her team won a championship against an Oakland team. Sadly, when she was offered a contract to play professionally, her mother would not allow it. The war and the demands of wartime economy brought unanticipated social change to the Logan Heights community. Women went to work in the canneries. Besides baseball, World War II forced Mexican American women into non-traditional occupations. Emma López was one of those women. She learned to dance flamenco at Neighborhood House, attended USO dances, and was president of the Don Diego Post Auxiliary. (Courtesy of Valentina "Tina" Hernández.)

As a young girl, Concha Estrada played third base on the all-girls team for the Neighborhood House. Neighborhood House built a baseball diamond specifically for the girls. Her brother, Mike Negrete, was the coach. She would leave the house with her shorts under her skirt or under her pants and change when she arrived at the field. The girls played against the Navy girls' team and other local girls' teams. Estrada remembered that some teams refused to play the "Mexican team." Those games were cancelled instead of forfeited, thus depriving the Mexican girls of a win. Coach Negrete was a member of the Toltecs, a club that promoted social activities to involve and educate Mexican Americans on political issues. The Toltecs held dances where those who voted in elections were allowed free entrance. (Courtesy of Maria García.)

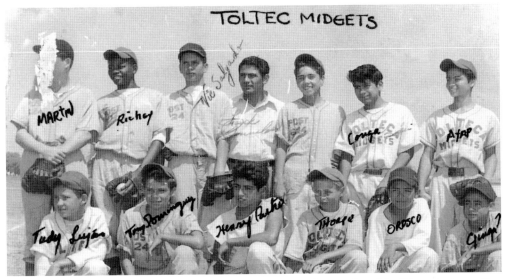

The 1947 Toltec Midgets were sponsored by the American Legion Post No. 24 in southeast San Diego. They won the championship that season. Frank Peñuelas originated the idea of the Toltec Club prior to World War II, utilizing athletics as a way to provide counseling and guidance for young people. He attempted to establish the club at San Diego State because Mexican students were denied membership to fraternities and sororities. After the war, the Toltec Club focused on social dances, baseball games, picnics, and involvement in the political process. (Courtesy of Tony Millan Jr.)

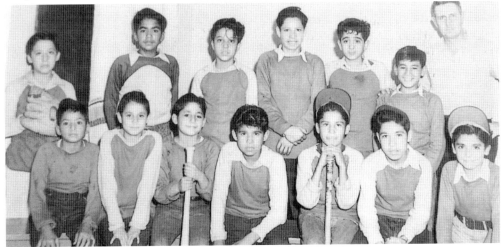

This is the 1940s Neighborhood House team under coach Merlin Pinkerton, which won several championships. Fernando "Chicky" Rodríguez played in Logan Heights and in Tijuana. Playing on both sides of the border was not unusual. Some families were sent to Mexico during the devastating repatriation of the 1930s. From left to right are (first row) Jimmy Penney, David Riveroll, Bobby Riveroll, Johnny Gastelum, Fernando "Chicky" Rodríguez, Chicky Ville, and Oscar Torres; (second row) Joe Castro, Manuel Penney, Adam Acosta, Bernard Hernández, Tony Núñez, ? Reyes, and Coach Pinkerton. (Courtesy of Maria García.)

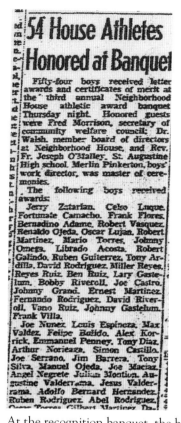

54 House Athletes Honored at Banquet

Fifty-four boys received letter awards and certificates of merit at the third annual Neighborhood House athletic award banquet Thursday night. Honored guests were Fred Morrison, secretary of community welfare council; Dr. Walsh, member board of directors at Neighborhood House, and Rev. Fr. Joseph O'Malley. St. Augustine High school. Merlin Pinkerton, boys' work director, was master of ceremonies.

The following boys received awards:

Jerry Zatarian. Celso Luque. Fortunate Camacho. Frank Flores. Bernadino Adame. Robert Vasquez. Renaldo Ojeda. Oscar Lujan. Robert Martinez. Mario Torres. Johnny Omega. Librado Acosta. Robert Galindo. Ruben Guiterrez. Tony Ardilla. David Rodriguez. Miller Reyes. Reyes Ruiz. Ben Ruiz. Lary Gastelum. Bobby Riveroll. Joe Castro. Johnny Grand. Ernest Martinez. Fernando Rodriguez. David Riveroll. Vano Ruiz. Johnny Gastelum. Frank Villa.

Joe Nunez. Louis Espinoza. Max Valdez. Felipe Balido. Alex Korrick. Emmanuel Penney. Tony Diaz. Arthur Norieaga. Simon Castillo. Joe Serrano. Jim Barrera. Tony Silva. Manuel Ojeda. Joe Maciaz. Angel Negrete. Julian Montion. Augustine Valderrama. Jesus Valderrama. Adolfo Bernard Hernandez. Ruben Rodriguez. Abel Rodriguez. Oscar Torres. Gilbert Martinez. Da...

Coach Merlin Pinkerton established a recognition banquet to celebrate the boys' sports accomplishments in 1945. Pinkerton came to San Diego in 1943 and became a father figure to many of the local boys from Logan Heights. Marcario "Mac" Colmenero refers to Pinkerton as the best thing that ever happen to the Neighborhood House. Virginia Sánchez, whose husband, Neno, was a regular at the Neighborhood House, believes that if it had not been for Pinkerton, many of the boys most likely would have found themselves in juvenile hall. The banquet was discontinued because of the increasing costs to hold the event. Coach Pinkerton lived on Cherokee Avenue in North Park and the boys would take the streetcars to his home to celebrate a victory with a weenie roast. Rubén Camacho recalled that if a boy got into trouble with the law, Pinkerton would appear in court to testify about the boy's character. (Courtesy of the *San Diego Union*.)

At the recognition banquet, the boys received their letters for sports. This 1948 letter was earned by Oscar Torres for baseball. Almost 70 years later, Torres still has his treasured letter. He was an outstanding athlete and earned letters in several sports. The first year, 1943, only 12 boys earned letters. Two years later, 44 boys earned letters. Records show that a total of 175 boys won sports letters. Oscar Torres loves telling the story that the boys invented the first slip-and-slide at the Neighborhood House. This was accomplished using the shower floor. The shower had a rim a few inches high around it. By placing towels over the drain, a pool of water several inches high would form. The boys took turns taking a running start before slipping and sliding all over the shower room. (Courtesy of Oscar Torres.)

Reynaldo "Nando" Ojeda was so proud of his baseball uniform that he kept it his entire life, demonstrating how important playing baseball was to him. The team was sponsored by Fentons' Cement Company, located near the East Village. The uniform is now a prized possession of his daughter Connie Ojeda Hernández. Nando Ojeda was born in 1928, the youngest of 12 children. He was born at home, on the site of what is now Perkins Elementary School. He and his wife, Connie, had five children. He worked as a journeyman lathe operator and as a city inspector. (Courtesy of Connie Ojeda Hernández.)

This early 1940s photograph shows Reynaldo "Nando" Ojeda wearing his baseball uniform. Reynaldo played trumpet in various local bands, including the Tipica, a well-known orchestra from the Logan Heights area. He later became involved with the Chicano movement, worked at the Neighborhood House, and was the first executive director of the Chicano Free Clinic. His last employment was as owner of his own construction company. As a boy during World War II, he was the "information officer" for the Tortilla Army, a group of boys five to 16 years old that formed to defend the barrio against a Japanese or German invasion. It was his responsibility to listen to the radio and report back to the Tortilla Army of any threat. The general was Manuel "Tortilla" Hernández. Bill López's chemistry set was used to make stick bombs. López later earned a master's degree in physics. To protect their school from being invaded, the boys dug a trench around it. Ojeda and his wife, Connie, both died in 1990. (Courtesy of Connie Ojeda Hernández.)

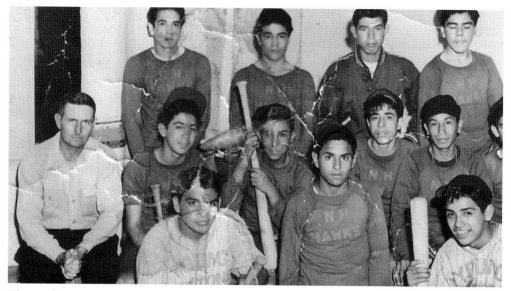

This early 1940s Neighborhood House team was the Hawks. From left to right are (first row) Ángel Negrete, Tony Díaz, and Reynaldo "Nando" Ojeda; (second row) coach Merlin Pinkerton, Joe Núñez, Vogi Adamo, Louie Espinoza, Robert Vásquez, and David Saterrian; (third row) Tony Silva, Celso Luque, Simón Castillo, and Joe Macías. (Courtesy of Connie Ojeda Hernández.)

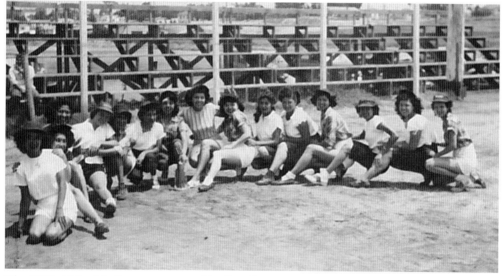

The 1950 girls' softball team sponsored by Don Diego VFW Post No. 7420 is, from left to right, Carolina Caballero, Illena Paredes Orozco, Mercy Gastelum, unidentified, Connie Serrano, two unidentified, Emma López, Alice Montejano, unidentified, Grace Lupían, Marcella Smith, Toni Aranjo, Rachael Ramírez, and Maddy Gonzáles. The Don Diego Post was named after a fictional character from the Del Mar Fair. Don Diego was a name used by Spanish actor Tom Hernández, who was hired to be a greeter and fair promoter after World War II. He played a dashing caballero. During the war, the fairgrounds had been used for military training. Tom Hernández was hired in 1947 and played Don Diego until his death in 1984. (Courtesy of Emma Araujo López.)

This may be the early 1970s men's Don Diego VFW team. Identified are Ralph López (first row, sitting), Joe Ramírez (first row, far left), Larry Lupían (second row, standing third from left), and Ernie Araujo (third from right, holding a cup). A war memorial sponsored by the Don Diego Post can be found in Chicano Park under the Coronado Bridge. Chicano Park and its murals are listed in the National Register of Historic Places. The park has flourished under the direction of the Chicano Park Steering Committee. The victory at Chicano Park gave the community the self-determination to also occupy the Neighborhood House. (Courtesy of Emma Araujo López.)

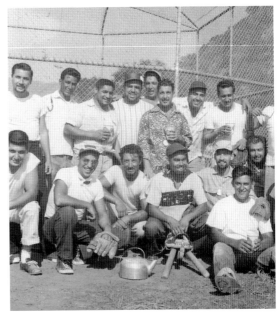

As vice president of Latino marketing for the San Diego Padres, Enrique Morones was the highest-ranking Mexican American in a major-league baseball franchise. He is seen here with Pres. Bill Clinton in the 1990s. Enrique was able to increase the Latino market from 50,000 to 85,000 fans. He assisted in establishing the first Major League Baseball store in Mexico. The store remains open in La Plaza Río in Tijuana and sells tickets to Padres games and Padres merchandise. (Courtesy of Enrique Morones.)

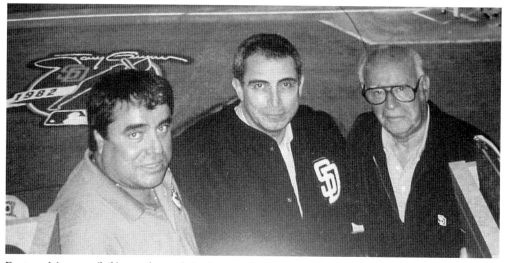

Enrique Morones (left) coordinated the first regular-season major-league baseball series in Mexico between the San Diego Padres and the New York Mets, played August 16–19, 1996, in Monterrey. The series was covered by ESPN. Morones made lasting relationships for the Padres and for himself. Today, he is director of Border Angels, a nonprofit organization dedicated to helping undocumented citizens. This picture was taken at a Padres game on September 22, 2001, and shows Morones, Ernesto Zedillo (center, then-president of Mexico), and Luís Morones, Enrique's dad. (Courtesy of Enrique Morones.)

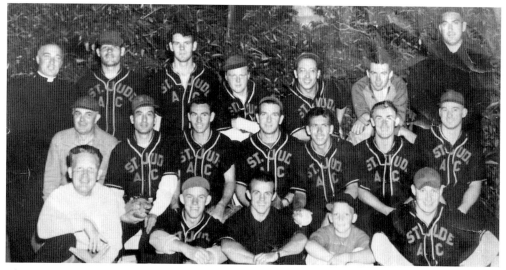

The 1950 St. Jude Parish Triple-A fast-pitch softball team was comprised of adults. One of the players, Tony Millan Sr. (third row, fifth from left, wearing glasses) played for two years and had a son, Tony Jr., who played for the St. Jude baseball team at third base, shortstop, and center field in 1952 and 1953. The St. Jude school team played against Our Lady of the Angels, St. Martin, Nazareth House, St. Didacus, and Blessed Sacrament. Tony Jr. later coached his son, David, at Blessed Sacrament in baseball. David's great-grandfather, Sam, was an outstanding player and coach in San Diego. (Courtesy of Tony Millan Jr.)

THE GOLDEN STATE

The Mexican-American War of 1846–1848 brought statehood to California in 1850. The 1849 Gold Rush in Northern California attracted thousands of people from all over the world. At the time of statehood, thousands of Mexicans lived in the Golden State. The first California Constitution was written in both Spanish and English. The state began as a bilingual institution. At the time, there existed an elite class known as Californios who owned vast lands granted them under both Spanish and Mexican rule. But through several controversial, and sometimes illegal, political and legal maneuvers, these Mexican families lost their lands and wealth. The Industrial Revolution that swept the nation after the 1860s made California an agricultural and industrial power, and this was followed by the tourism, oil, railroad, and film industries.

From the beginning, Mexican residents and their offspring, along with other people of color, have confronted outright prejudice and discrimination in education, employment, housing, medical care, politics, economics, language, property, and recreation. Yet the history of Mexican Americans is the history of unrelenting perseverance for their human rights as first-class citizens. The baseball and softball fields were unique places where there was at least some semblance of a level playing field between Mexicans and Anglos.

Mexicans and Mexican Americans clearly demonstrated that they could run, hit, field, and pitch as well as anyone else, and sometimes even a little better. In the past, this book series has shared stories of ballplayers who testified that all of life's lessons for success were learned on the ball field, and equally important, the mental, physical, and emotional strengths achieved on the diamond translated to winning in the workplace, on the playground, in the political arena, on main street, on the battlefield, and on the home front.

Twenty years after statehood, Mexican Americans were already playing baseball in Los Angeles in 1870. Some of these players were the descendants of the Californios. This inspiring legacy of baseball has been painfully overshadowed by bigotry and intolerance. The ongoing struggle for justice and respect among California's Mexican Americans has taken on many forms over the decades. Since 2006, the Latino Baseball History Project has opened up a new public conversation promoting this quest for first-class citizenship through the astounding history and social contributions of Mexican American baseball and softball to California.

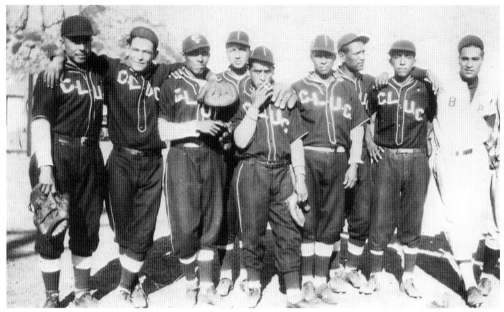

José Jiménez (far left) and José Castaneda (fourth from left) stand alongside their Chatsworth teammates in 1930. Born in El Paso, Texas, in 1908, Castaneda moved with his family to Chatsworth in the 1910s and worked on citrus farms. His father, Manuel, worked as a *traquero* for the Southern Pacific Railroad in Chatsworth before he was struck by a train under mysterious circumstances in 1926. José Castaneda ignited a family passion for baseball that he passed down to grandson Art Castaneda. (Courtesy of Art Castaneda and Rachel Jiménez.)

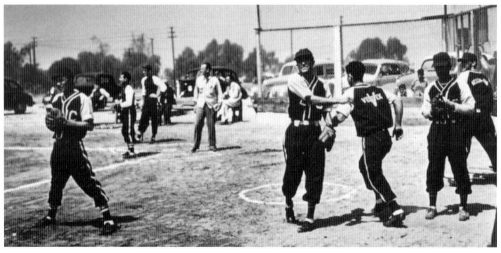

Members of the Lankershim Village Club team warm up at the Orcasitas barrio field in the 1940s. The Orcasitas barrio was located between Arminta Street, Lankershim Boulevard, Stagg Street, and Beck Avenue in what is now Sun Valley. Player Tony Servera built the field from a vacant lot. In 1950, the team wrote to the Los Angeles City Council requesting the city to acquire land nearby for a public playground, but the plan never materialized. This land now consists of industrial buildings, apartments, and the Sikh Gurdwara of Los Angeles. (Courtesy of Tony Servera.)

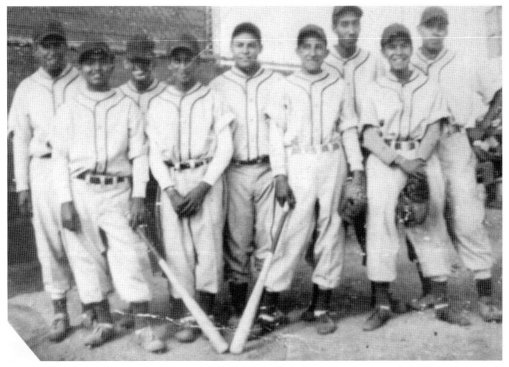

Benny Salas stands at center in this Pacoima youth team photograph. Salas played baseball since he was a little kid, coming from a long line of San Fernando Valley baseball players. His father Ignacio played for the Pacoima Merchants, while uncles Elijio, Nick, and Vince Salas played for the San Fernando Missions and numerous other Valley teams. Benny later played for the Pacoima Athletics. His amateur baseball career stopped temporarily when he served in the Korean War. (Courtesy of Benny Salas.)

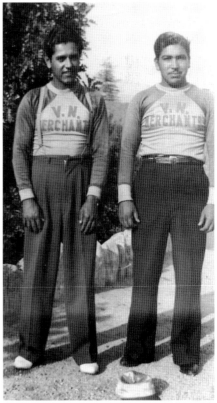

Van Nuys Merchants players and best friends Joe Ybarra (left) and Mike Palacios (right) pose in 1942. Palacios was born in 1915 in Kingsbury, California, where his parents worked as seasonal agricultural workers. Parents Ángel and Pasquala settled in Van Nuys shortly after crossing the Mexican border in 1913, living at 14712 Delano Street. The Van Nuys barrio existed between Erwin Street, Oxnard Street, Sepulveda Boulevard, and Cedros Avenue. Much of the neighborhood now consists of multifamily apartment buildings. (Courtesy of Mike Palacios.)

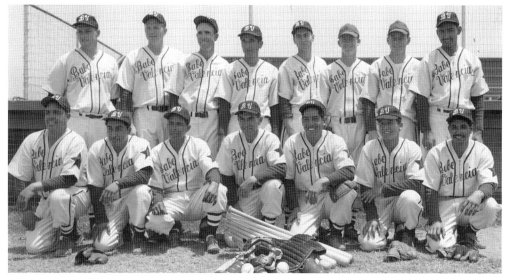

The Canoga Park Babe Valencia All-Stars included Babe Valencia (first row, center) and Joe Yescas (first row, third from right). Valencia was a household name to West San Fernando Valley baseball fans from the 1930s to 1950s. The Canoga Park manager consistently guided his Canoga Park Merchants and Babe Valencia All-Stars teams to the top of municipal league standings. In 1948, his team scored 77 runs in just three games, beating the LA Stars 30-6 and the Canoga Park Cubs 23-5. (Courtesy of Sylvia Valencia Wiltz.)

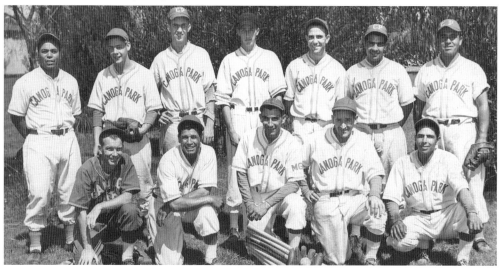

The Canoga Park Merchants often reigned supreme over Valley and Southern California teams. This team picture features Joe Miranda (first row, second from left), Babe Valencia (first row, center), and Tony Murillo (second row, far left). The Murillo family is well known throughout Valley baseball circles. Tony Murillo's sons Herman, Alfred, Arnold, Bill, and Gilbert all played baseball at Canoga Park High School. His brother Joe also played in the 1940s. Other talented players included Johnny Cano, Ritchie Encinas, Raul Franco, Mike Gonzáles, Pete Gonzáles, and Vic Gonzáles. (Courtesy of Sylvia Valencia Wiltz.)

Babe Valencia was born in Arizona in 1912 and later settled in Canoga Park. After managing Canoga Park teams for decades, he passed on his baseball leadership skills to his son Armando, who also excelled at baseball as an All-Valley shortstop in 1975 for Canoga Park High School. Armando Valencia managed his daughters' fast-pitch softball travel teams, winning the 14-and-under national triple crown championship in 2000. A firefighter, Valencia also won softball gold medals in the Los Angeles Fire Department Olympics. (Courtesy of Armando Valencia and Sylvia Valencia Wiltz.)

Ritchie Encinas broke into San Fernando Valley baseball in 1934, playing for the Reseda Merchants under manager Pop Kline. The Reseda Merchants won the 1939–1940 Los Angeles City Playground winter league championship. Encinas also starred for the Canoga Park Merchants, led by his half-brother Babe Valencia. In the late 1940s, Encinas served on the board of directors for the West Valley Softball League and managed in the prestigious *Van Nuys News* West Valley game, played in front of over 3,500 spectators at Reseda Park. (Courtesy of Armida Encinas and Richard F. Encinas.)

Rudy Regalado (right) was the first Mexican American player from the San Fernando Valley region to reach the major leagues. The Glendale High School shortstop hit an incredible .561 as a senior. In 1947, he was chosen as one of two representatives from Glendale High School to play in the Hearst Sandlot Classic, held at the Polo Grounds, with special guest Babe Ruth in attendance. After continuing at USC, he played for the Cleveland Indians between 1954 and 1956. (Courtesy of Ron Regalado.)

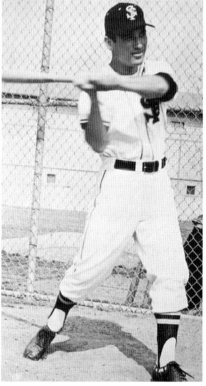

Fred Rico shows off his swing in 1962 as a star player for the San Fernando High Tigers. The astounding high school athlete captained both San Fernando baseball and football teams as a senior and won City Section baseball player of the year and All-Valley football halfback awards. Sportswriter Pete Kokon of the *Valley Times* thought the power-hitting Rico was the best athlete he had seen in his years covering the San Fernando Valley. Rico signed with the Baltimore Orioles in 1964. After playing in the minors, he made a strong impression in his 1969 major-league debut, batting third for the Kansas City Royals and collecting base hits in his first two at-bats. Rico is featured on a Royals rookie stars baseball card in the 1970 Topps set. After his baseball career, he worked as a Los Angeles County marshal. (Courtesy of San Fernando High School.)

Rosalind Beltrán Roof (left) was born in Los Angeles and grew up in Chino. She started playing softball at Chino High School, making the high school all-star team at third base the last three years. She played with another outstanding player, Stella Briones (not shown), after high school. Briones's father and brothers were excellent players in the Pomona Valley. Paula Duncan (right) is seen here with Rosalind on a traveling Double-A team. Duncan was the team catcher. Rosalind worked for the Claremont School District for 30 years. Today she watches her grandchildren, River and David, play ball. (Courtesy of Joe Romero.)

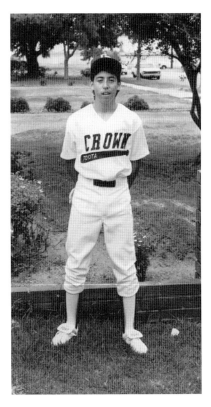

Eddie Roof was born in Pomona and is one of the sons of Rosalind Beltrán Roof, who was an outstanding woman softball player in the Pomona Valley. Eddie Roof played center field and his twin, Tommy, played catcher in Little League in nearby Upland in the late 1970s. Eddie later played Pony, Colt, and Senior Leagues. He played in Marysville in Northern California and then returned and played in Upland and Montclair. He married and has three boys (Kevyn, David, and Eddie), whom he coaches, especially David, a switch-hitter. David played Little League for the Angels and the Pirates and made the all-star team. Because of his outstanding skills, he was selected to play on a traveling team as an outfielder and pitcher. Eddie has worked for the Frito Lay Company in Rancho Cucamonga for the last 20 years. Besides his mother, Eddie has other family members who were outstanding players, including his uncle Joe Romero, who was an exceptional player in the Inland Empire and Pomona Valley, playing for the Claremont Barons, San Bernardino Mannys, and the Upland Angels in the early 1960s. (Courtesy of Joe Romero.)

Rudy Mendoza, seen here in Colton, was born in Upland and grew up in Alta Loma, where he attended high school and graduated from Chaffey Community College. Mendoza played Little, Pony, and Colt Leagues, high school, American Legion, and college ball. He was an outstanding hitter and hardly ever struck out, winning the Eastern and Western batting titles. Mendoza played at Memorial Park for the Upland Angels at four different positions. His father, Fortino Mendoza, had been an outstanding catcher with a strong arm. When Rudy played for the Angels, his dad was the third base coach. Rudy now lives in Texas, and his dad lives in Arizona. (Courtesy of Joe Romero.)

Tom Rojo (right) is seen with his dad, Joe. Tom was born in Upland and played catcher in Little, Pony, Colt, and Senior Leagues, at Upland High School, and in the American Legion. He played for the semi-professional Upland Angels for four years and later played ball in Mexico in Tijuana and Rosarito Beach. Tom had a good arm and excellent speed. His father coached for nearly 12 years with the Upland Little League. Joe drove Tom to Mexico to play games. Later on, Tom was old enough to drive to Mexico with his teammates. Tom is married with one son and two daughters and is a barber and karate instructor. (Courtesy of Joe Romero.)

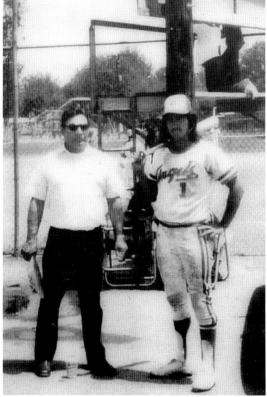

Members of the Eastside Beer team were interviewed in 1956 by radio host Milt Nava (not pictured). At the time, KWKW was one of the largest Spanish-speaking radio stations in the United States, even broadcasting Dodgers games when they first moved to Los Angeles from Brooklyn. From left to right are (first row) Wally Poon, Che Che Hernández, manager Pat Molina, Ray Puente, and Pepe Figueroa; (second row) Larry Silva, Joe Miranda, Eppie González, unidentified, and Rudy Martínez. (Courtesy of Bob Recendez.)

Gene Aguilera (first row, third from left) played second base for the Beavers at DeMille Junior High School in Long Beach. They won the Boy's Baseball League Championship in 1966 but lost the title game in 1967 due to a controversial ruling by league officials. Aguilera, originally from East Los Angeles, graduated from the University of Southern California, became a bank vice president and music historian, and wrote Mexican American Boxing in Los Angeles. His father, Lorenzo Aguilera Jr. (third row, third from right) coached the Beavers and later became league president. (Courtesy of Gene Aguilera.)

The 1977–1978 Lugo team played in the Victorville, California, Men's Softball League. They were an outstanding team with excellent pitching, timely hitting, and speed on the base paths. Sitting in the front row is coach Gilbert Lugo; from left to right are (second row) Héctor Lugo, Manuel Cordero, Sergio Lugo, Ray Saavedra, Bill Quimby, and Alex Cruz; (third row) Mike Lugo, Albert Lugo, Mike Bernal, Armando Quiñónez, Mike García, Randy Carter, and Louie Rivera. (Courtesy of Bob Quintanar.)

Big League Baseball

Williamsport Pennsylvania

DAVID VARGAS
WEST BARSTOW
THIRD BASE

having acquitted himself creditably in the skills of baseball, the spirit of teamwork and in wholesome deportment as a participant in the Big League World Series is presented with this

Certificate
of
Champions

David Vargas was affiliated with the World Series District 49 Big League All-Star champions in 1969. As the only Mexican American who made the All-Star team, he traveled to Winston-Salem, North Carolina, where the team won the championship at Ernie Shore Park. This is his championship certificate. (Courtesy of David Vargas.)

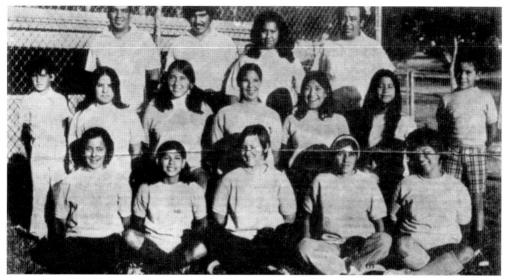

The 1972 Barstow Loboettes won the championship after an undefeated season. The team drew large crowds. From left to right are (first row) Carol Chávez, JoAnn Islas, Kathy Harris, Loretta Vargas, and Tita Griego; (second row) batboy Ricky Griego, Teresa Gallegos, Barbara García, Pat Esquevel, Jackie Acosta, Gloria Islas, and batboy Raymond Esquevel; (third row) coach Pete Esquevel, pitching coach Rubén Lara, team captain Irene Robles, and manager Salvador Esquevel. Missing are Martha Milroy, Dinah Griego, and Rosemary Pérez. (Courtesy of David Vargas.)

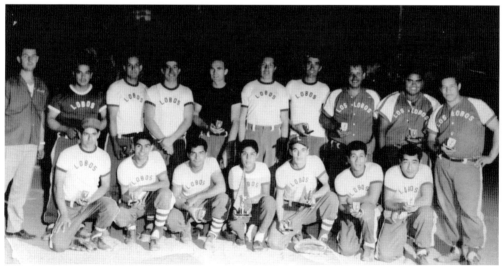

In 1965, Los Lobos won the fast-pitch city championship in Barstow, playing their games at Hobbs Field. The team players were raised on Clark Street in the barrio. Their rivals came from nearby Victorville. Their sponsors included Martha's Amigos Café, Rodríguez Market, and Charros Cantina. From left to right are (first row) Félix Robles, Joe Rentería, Arnold Soto, Ralph Ribera, Eddie Ribera, Tony Rentería, and Cruz Soto; (second row) manager Charlie Green, Raúl Rodríguez, Frank Yslas, H. Lugo, Bill Larson, Dick Hisquierdo, Danny Lugo, Tony Yslas, Hank Espinoza, and Al López. (Courtesy of David Vargas.)

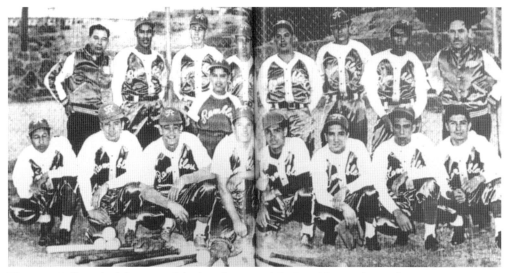

The year 1947 marked the start of the long history of the Ramblers in the High Desert community of Barstow, California. The players grew up in the same neighborhood and attended the same schools and church, and they went into the military together. Several played military ball. From left to right are (first row) ? Duran, Tony González, Ralph Cases, Ben Andrade, Daniel Hernández, Louis Hernández, Lawrence Duarte, and Gilbert Lavato; (second row) Melguides Mares, Chevo Cedillo, Pete Castelum, Manuel Gonzáles, Robert Yures, Peter Duran, Juvenile Negrete, and Joe Duran. (Courtesy of David Vargas.)

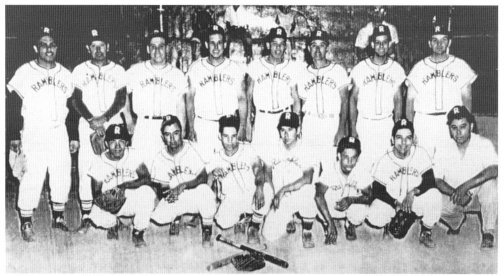

The Ramblers were originally named Los Lobos (the Wolves), but they could not afford to purchase new uniforms and were given used uniforms by the Ramblers. This 1955 Ramblers team was comprised mainly of World War II and Korean War veterans. From left to right are (first row) Arnold Soto, Aristeo Vargas, Al López, Félix Robles, Ricky Carbajal, R. Hernández, and manager Ernie Duarte; (second row) Danny Hernández, John Sánchez, Aldolfo Ribera, Tony Yslas, Johnny Martínez, Bobby Zarmaino, Frank Yslas, and Jack Sallvan. (Courtesy of David Vargas.)

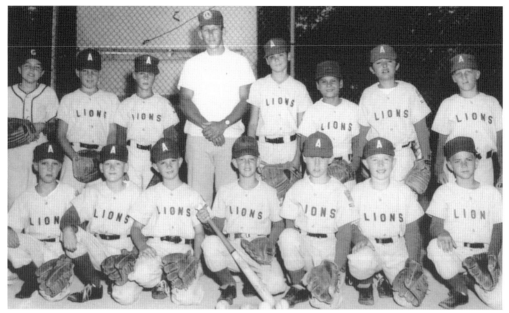

The 1958 Little League Lion Angels played at Folgoleson Park in Barstow. The team was sponsored by the Lions Rotary Club, and they were the league champs this year. After each game, they were treated to free sodas and ice cream at the local Foster's Freeze. David Vargas (second row, second from right) started playing baseball at an early age in the Tortilla Flats barrio. His father, Mike Vargas, coached David on many teams. David later played ball in high school and college. He played both shortstop and pitcher. (Courtesy of David Vargas.)

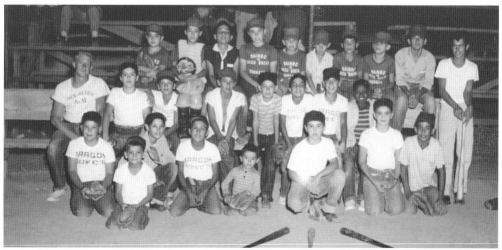

Fidel Reyes Jr. was an outstanding player from Compton. He played on the El Segundo Little League White Sox and in middle school. His mother, Dora Padilla Reyes, was born and raised in Socorro, New Mexico, 74 miles from Albuquerque in the Rio Grande Valley. The Reyes family made summer trips to visit her sister Joquina. One summer in the late 1950s, Fidel Jr. (second row, second from left) played on the Socorro team with his cousins Billy and Herman Trujillo. (Courtesy of Ricardo Reyes.)

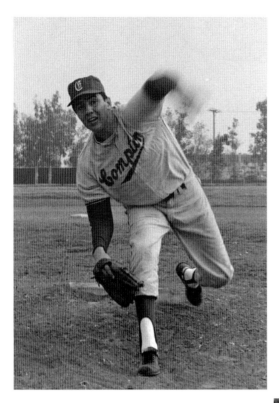

Fidel Reyes Jr. was a standout player at both Centennial and Dominguez Hills High Schools. His father practiced with him nearly every day. Fidel Jr. played at Compton Junior College in 1965, where he pitched and played the outfield. He played extra games at Jackie Robinson Stadium. He and his brother, Ricardo, recalled that Duke Snider, a Compton native, invited Pee Wee Reese, Gil Hodges, and other Dodgers to meet his mom. The kids were often present requesting autographs. Fidel Jr. was drafted into the Army in 1967 and did his basic training at Fort Bliss, Texas, and medic training at Tacoma, Washington. His son, Justin, was also an outstanding ballplayer. (Courtesy of Ricardo Reyes.)

Justin Reyes, son of Fidel Reyes Jr., played Little League and Pony League in Costa Mesa, California, and later at Costa Mesa High School. He was an outfielder known for his power hitting during the 1970s and 1980s. He still plays adult softball. His family background is Mexican American and Native American. On his father's side, the family has deep roots in Compton, California. The original Spanish land grant covered over 43,000 acres including the current communities of Compton, San Pedro, Wilmington, Watts, Palos Verdes, Torrance, Redondo, Hermosa, and Manhattan Beaches, Paramount, Harbor City, Long Beach, and Willowbrook. Mexican Americans worked in several industries including the Navy and commercial shipyards, ranching, agriculture, oil refineries, trucking, auto, and tire factories. Since the 1930s, Mexican American baseball and softball has flourished in these communities. (Courtesy of Ricardo Reyes.)

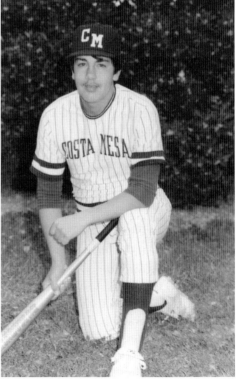

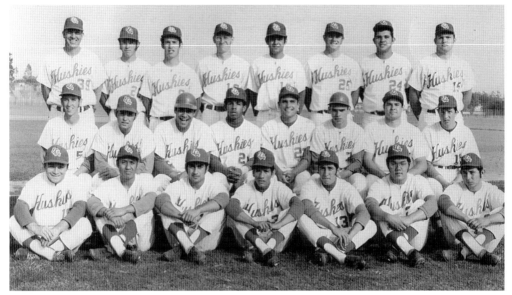

Coach Bob Hertel (third row, fourth from left) managed the 1970 East Los Angeles Junior College Huskies team and coached for 27 years. He played at USC and in 1952 with the New York Yankees. Half of the Huskies were Mexican Americans representing several high schools, including Alhambra, Bell, Cathedral, Garfield, Lincoln, Montebello, Mark Keppel, Roosevelt, San Gabriel, and South Gate. The players included Jack Arenas, Al De La Rosa, Marty Provéncio, Nick Medrano, Joel Palomares, Raúl Morales, Alex Santana, Rick Apodaca, Nicky Escamilla, Steve Romero, Randy Chávez, and Richard Gonzáles. (Courtesy of Jackie Arenas.)

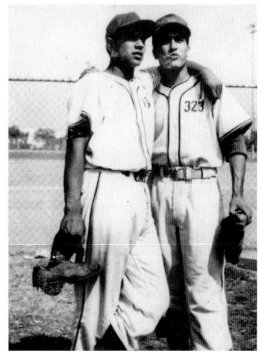

Tom Robles (left) sold boxing programs as a youngster at the Olympic Auditorium in 1947. He eventually became the Los Angeles City First Team catcher in 1953, taking his Garfield team to the city championship. Bill Miranda (not shown) remembers playing ball with Tom at Laguna Park when they were five years old. Tom Robles played in Mexico and in the Dixie Leagues in the Deep South. Ángel Figueroa (right) was an outstanding high school player at Garfield and played ball in Salinas, California, and Las Vegas, Nevada. He became a scout for the Pittsburgh Pirates and St. Louis Cardinals, befriending hall-of-famer Stan Musial. (Courtesy of John Robles.)

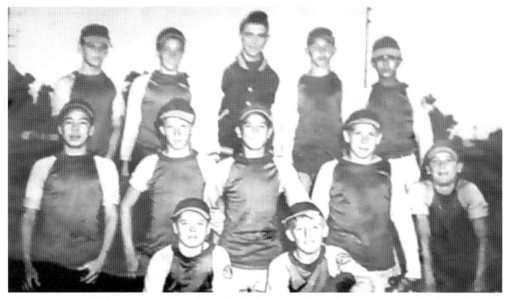

The 1948 General Electric team won the softball championship. The games were played at Salt Lake Park in Huntington Park and included teams from Bell and Maywood. Only three Mexican Americans were on this team, having been recruited out of Fresno Playground in East Los Angeles. After the team won the championship, league rules were changed to disallow players from outside the area. The three from East Los Angeles are Bobby Recendez (second row, center), Joe Gaitan (second row, left), and Fernando Farfán (third row, right). (Courtesy of Bob Recendez.)

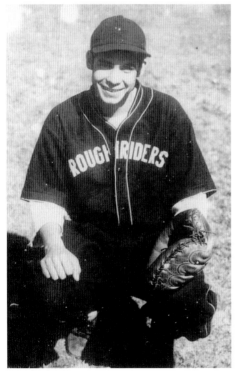

Candido Madrid González was born in 1913 in the mining town of Sutters Creek, the oldest of eight children. His father, Candido Sr., moved around a lot looking for work for his big family. The family eventually settled in Boyle Heights in East Los Angeles. At the age of nine, Candido sold newspapers and shined shoes, helping the family financially. Any free time was devoted to baseball with his brothers Joe and Freddie. Joe and Candido were outstanding players at Roosevelt High School under coach Charles "Coney" Galindo. In retirement, he loved his Dodger Dogs and cold beer at the stadium and rarely missed a game on TV with his wife, Margaret. He passed away in 1987. (Courtesy of Christina Gillett.)

Efrén Montijo was born in California in 1894. His Californio ancestors fought against the Spanish during Mexico's struggle for independence. Montijo was raised around Vernon and Huntington Park. He played ball in grammar school and studied drama and languages in high school along with sports. He received a scholarship to Occidental College, where he was an outstanding athlete in baseball and track. He was scouted by the Chicago White Sox but served in France during World War I, where he was a prisoner of war. He spoke fluent French and German. He married Antonia Núñez in 1919, and they had five children, Eugenie, Efrén Jr., Charlotte, Norina, and Henry. (Courtesy of Charlotte Montijo Sauter.)

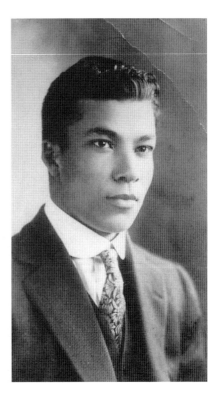

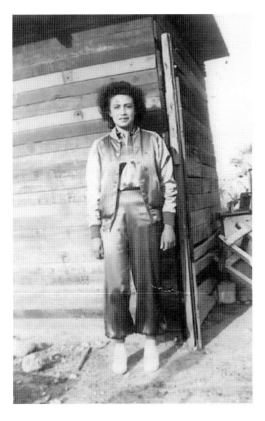

Maggie Guzmán was born in 1931 in Irwindale. At a very young age, she fell in love with baseball and played catcher. One of her favorite pitchers was Velia Silva. They won the 1947 championship in their first season. They were scouted and recruited by the nearby Baldwin Park Royals, a semiprofessional team that traveled throughout the United States, Mexico, and Canada. Guzmán made the headlines in the local newspaper the *Tribune* and on television Channel 11. The Royals later played night games at Burbank's larger Atkins Park. (Courtesy of Maggie Guzmán.)

The Chicago Cubs were interested in Joe "Foxie" Saucedo for his hitting, pitching, and stealing bases. He played in high school and the city leagues on Catalina Island, where he was born, and coached the first Little League champions on Catalina Island, Carson Plumbing, in 1961. From left to right are (first row) Salvador Hernández, Larry Hernández, Roger Cadman, Pastor López, Anthony García, and Stanley Hernández; (second row) Tom Laurin, Charlie Hernández, Greg Harkness, Robin Miller, Richard Smith, Casey Donaho, and coach Joe Saucedo. Saucedo's brother and sisters were also outstanding players. (Courtesy of Marcelino Saucedo.)

The Castel De Oro brothers, Norbert (center) and Tommy (right), played in the early 1940s for Local Union No. 630 and with the city leagues in El Sereno. They both played catcher but were versatile enough to play other positions when needed. In addition to baseball, they loved boxing. Both were welterweights and fought at the Olympic Auditorium and the Hollywood Palladium. Norbert boxed in the Navy during World War II. He was employed by the Los Angeles Produce Market. He was the second child of Louise and Sylvian Castel De Oro, immigrants from Mexico. Norbert's father died at an early age, and he had to quit Jefferson High School to be the sole provider for his mother and younger siblings. The player on the left is unidentified. (Courtesy of Jaime Castel De Oro.)

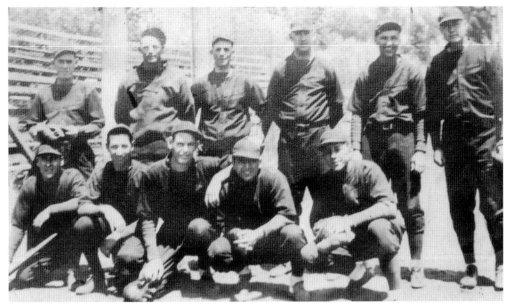

John "Juan" Martínez (standing far right) was born in Fillmore, and later the family moved to Gonzáles, along Highway 101. Martínez played baseball and softball for 40 years. He landed on Normandy during D-Day. He served with the Fourth Army and also saw action at the Battle of the Bulge. He won the Purple Heart twice. His son, Juan, has been active with social issues and causes since the 1960s and has collected memorabilia highlighting the Chicano movement in Gonzáles and other surrounding communities. (Courtesy of Juan Martínez.)

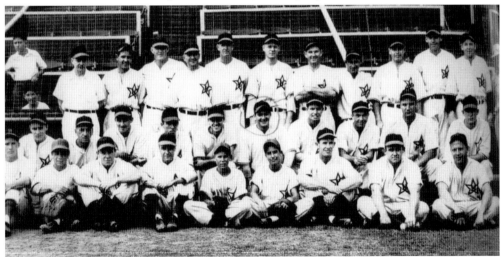

Freddy González was born in 1922 in Yuma, Arizona, and soon after, the family moved to East Los Angeles. He played lots of ball in parks and schools and later received a scholarship to the University of Santa Clara. During World War II, González played ball with a Coast Guard team. His four brothers, James, Ernest, Joe, and John, also served during the war. Sadly, Ernest was killed and John wounded. Freddy also played ball in Pueblo, Mexico. After the war, Freddy (second row, center) played for the Pacific Coast League Hollywood Stars. (Courtesy of Jim González.)

Victor Gamboa was born 1952. His father, Gilbert, was born in Mesilla, New Mexico; his mother, Maria Estela, was born in El Paso, Texas; and their three sons, Gilbert Jr., Victor Oscar, and Ricardo, were born in El Paso. The family moved to Lincoln Heights in 1960 and three years later moved again to Silver Lake, near Los Angeles. Victor (first row, left) played for the 1963 Hollywood Phillies Little League team, the only Mexican American on the team. (Courtesy of Victor Gamboa.)

The 1970 Los Angeles Wilson High School team was California Interscholastic Federation champions. Victor Gamboa played second base. Gamboa had a tryout with the Los Angeles Dodgers when Walter Alston was the manager. He was later part of the All-American Vancouver baseball team that won the bronze medal at the Olympic Sports Festival in Baton Rouge, Louisiana. There were other Mexican Americans on this Wilson team, including Al Moto, Jess Rentería, Mike Robles, Vic Bernal, Steve Hernández, and Dan Hernández. The A's, Padres, and Angels drafted several of these players professionally. Hernández was the Player of the Year. (Courtesy of Victor Gamboa.)

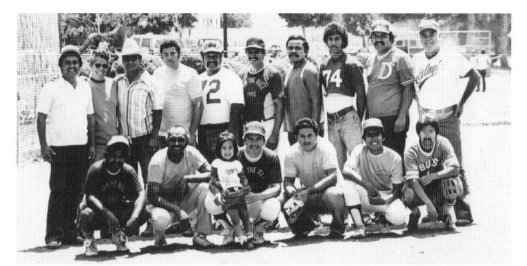

The 1971 Hazard Park All-Stars represented the Los Angeles Men's Fast Pitch League. Most of these players were originally from El Paso. The players included Mike Ríos, Rudy Orosco, Jaime Farfán, Lance Rubio, and Gilbert Gamboa Sr. (second row, far right). Gamboa's son Gilbert Jr. played for an international program in which the El Sereno Angels traveled to Sinaloa, Mexico. This collaboration remained for years. Gilbert Jr. (not pictured) was an exchange student in high school to Helsinki, Finland, where he played baseball and track. After graduating from high school, Gilbert Jr. played softball in East Los Angeles and El Paso. (Courtesy of Victor Gamboa.)

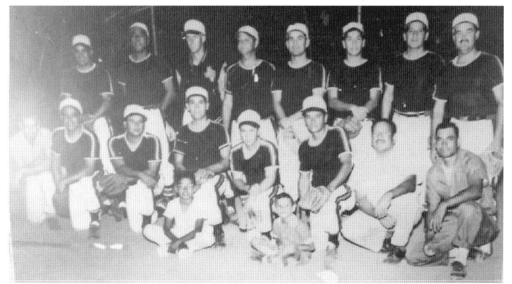

The Landeros, from El Paso, were back-to-back champions in 1958 and 1959. Gilbert Gamboa Sr. (second row, far right) played first base and catcher. His nickname was "Canario" (canary) because his mom once made him a yellow uniform. Other players included Kiki Gómez, Alfred Mena, and John Huerta. The manager was Veto Gómez, and the batboy was Gilbert's son Victor. The team sponsor was the 3115 Café, located on the famous Alameda Street. Most of the players have been inducted to the El Paso, Texas, Hall of Fame. (Courtesy of Victor Gamboa.)

Jack Arenas (second row, second from right) coached his son Joaquín (first row, third from left). Jack was very active with youth ball and travel ball. He worked 41 years in the music industry for CBS Records, Sony Music, Capitol Records, and Universal Music Group. Coach John Ávila (second row, far right) is pictured with daughter Liela (first row, second from left). Ávila was the bassist for the rock group Oingo Boingo. The team mom was Rita Biggerstaff (first row, second from left), pictured with son Steven (second row, sixth from left). (Courtesy of Jack Arenas.)

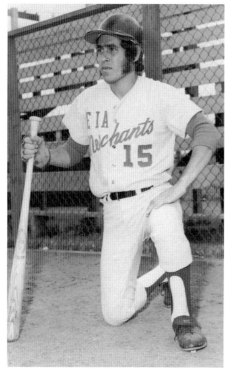

Ray Lara waits his turn to bat during a game in Tijuana in 1971. The East Los Angeles Merchants traveled extensively throughout Mexico, playing local teams in Chihuahua, Delicias, Agua Prieta, and Cananea. Lara played center field on a team that was comprised of current and former professional players, many from Lincoln High School in Los Angeles. Ralph García, Bobby "Babo" Castillo, and Freddie Martínez, all from Lincoln, pitched in the major leagues. Lara's potential professional career as a pitcher was tragically cut short due to a hunting accident to his pitching hand. He was born in Chihuahua, Mexico. His father was a policeman and later made a career as an auto mechanic. His mother, Avelina, raised four children, including Fred, who served in Vietnam. Brother Jess graduated from the University of California at Los Angeles. While at Lincoln, Ray set a city earned-run average record of 0.47 that still stands. (Courtesy of Ray Lara.)

Jack Arenas has had a distinguished career as a player and youth coach. He played youth ball with the Baldwin Park, California, Blue Jays, including playing teams in Mexico. He later played at Lincoln High School, where the team won the Northern League title in 1970. Two years earlier, Arenas was selected to the First Team All-Star as a shortstop. After high school, he played ball at East Los Angeles Junior College and with several community teams, including the California Stars and East Los Angeles Merchants. After his playing days, he became a youth coach. (Courtesy of Jack Arenas.)

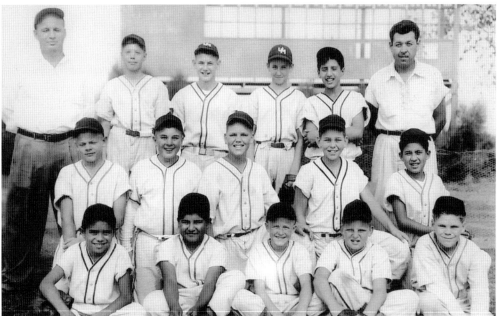

The 1953 Upland, California, All-Star team had several outstanding players. From left to right are (first row) Winston Velacino, David Guerro, and three unidentified; (second row) Kenny Storms, Johnny Lawless, unidentified, Gary Moore, and Joey Valadez; (third row) unidentified, Louie Smuts, Bobby Stobe, unidentified, Ralph Ramírez, and coach Jigs Valadez. Ralph Ramírez's brother, Albert Ramírez, played for the Cucamonga Merchants in the 1950s. (Courtesy of Ralph Ramírez and Ray Rodríguez.)

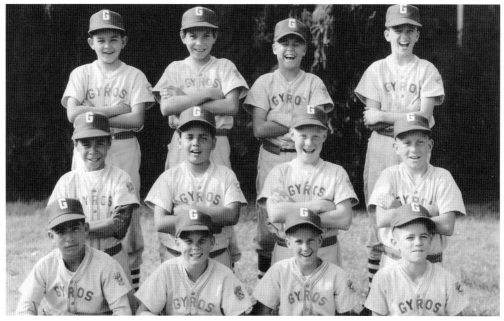

The 1963 Gyros Little League team played in the Vineyard and Citrus Leagues in Cucamonga. Several Mexican Americans were on the team, including Ernie Viveros (first row, far left), Paul Carbajal (second row, left), Karl Abril (second row, second from left), Richard Hernández (third row, left), and Mando Rodríguez (third row, second from left). Karl Abril was the nephew of "Los Cuates" (the twins), Manuel and Ernie Abril, who played for the Colton Mercuries, for teams in Mexico, and in the military during the Korean War, when they were photographed with Marilyn Monroe during her famous visit. (Courtesy of the Abril family and Ray Rodríguez.)

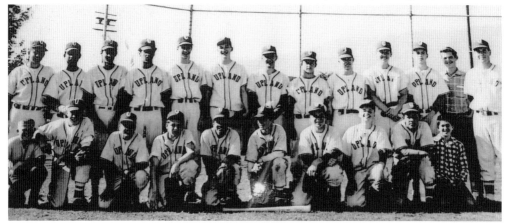

Upland High School went undefeated in 1958. Several Mexican American players made major contributions, including Junior Fuentez (first row, fourth from right), Ray Jiménez (first row, second from right), Jesse Martínez (second row, second from left), John Vásquez (second row, third from left), and Ralph Ramírez (second row, fourth from left). Ralph Ramírez's father, Concho Ramírez, worked for the El Cinco de Mayo Quality Meat Market for many years. The market sponsored several teams in the Cucamonga region. (Courtesy of Ralph Ramírez and Ray Rodríguez.)

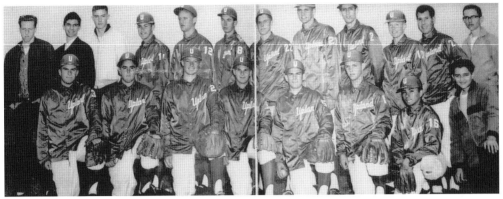

The 1962 Upland High School varsity team were defending champions of the Tri-County League. The schools that made up the league were Corona, Claremont, Bonita, Montclair, Rubidoux, Eisenhower (Rialto), Chino, and Upland. Many of these schools had two to five Mexican American players. Rey León (first row, second from right) came from a family of outstanding players. Rollie Fingers (second row, fourth from right) went on to play for the Oakland A's. Not shown are Jim Ledesma and Ralph Santos, two outstanding Upland players. (Courtesy of Rey León.)

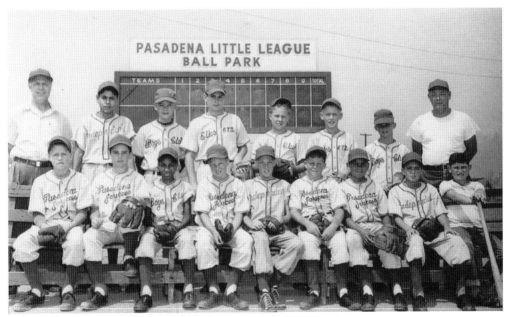

In 1952, this was the first Pasadena Little League team for boys living east of Hill Street. All the games were played at Victory Park, which was named in tribute to the men from Pasadena who fought in World War II. Carlos Salazar (second row, second from left) represented his team sponsor, the *Pasadena Independent Star-News*. Carlos's father, Dave, was an outstanding player throughout California, Arizona, and Mexico. Carlos's uncle, Mike, played and owned the baseball diamond near the San Gabriel Mission. (Courtesy of Carlos Salazar.)

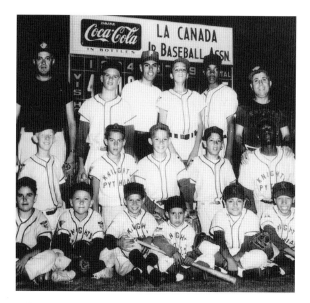

This 1959 California Junior Baseball Association team is seen here. Two grandsons of Dave Salazar, a player during the 1920s and 1930s, were on this team: Darrell Evans (second row, center) and Jerry Ashcraft (first row, far left). Evans played major-league ball for 20 years. Both played at Pasadena Community College in 1967, when the team won the state championship. Evans was selected the Most Valuable Player of the game and Ashcraft was the winning pitcher. Carlos Salazar (third row, third from left) was the assistant coach and the son of Dave Salazar. (Courtesy of Carlos Salazar.)

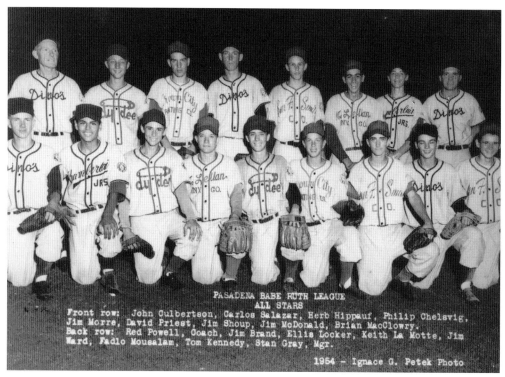

Carlos Salazar is seen in the first row, second from left. Salazar was a member of the 1954 Pasadena Babe Ruth All-Star team, playing against the Arcadia All-Stars during the state Babe Ruth playoffs. Pasadena beat Arcadia and later Fresno, but lost to Oakland at Gilmore Stadium, the home of the Hollywood Stars. Oakland won the Babe Ruth World Series in Austin, Texas. (Courtesy of Carlos Salazar.)

FIELD OF DREAMS

In the first nine books on Mexican American baseball and softball, the coauthors have included a chapter entitled Field of Dreams, presenting players as they look today. Most are in their 80s, and several have reached their 90s. The oldest ones were born in the 1920s. These ordinary men and women made—and continue to make—extraordinary contributions to their respective communities. While the books have showcased over 2,000 remarkable photographs from countless communities throughout the United States, the captions have focused on other interesting aspects of their remarkable lives. For example, these men and women contributed to the economic prosperity of this country, despite discriminatory labor practices. Many were union leaders who fought for better wages and working conditions. Moreover, they were active with civil rights organizations challenging housing, educational, and employment policies that treated Mexican Americans as second-class citizens.

These ballplayers also responded to the military call during World War I, World War II, Korea, and Vietnam. They did not shy away from their patriotic duties on the battlefield or on the home front, working in defense plants and other civilian activities such as the Red Cross and with their local USO. These former players were highly decorated for their service, and many gave the ultimate sacrifice. They were and are outstanding fathers and mothers, grandparents, and now great-grandparents. They have passed down their baseball and softball skills and knowledge to four or more generations of players. Many became school and community coaches, soliciting and donating funds from their own pockets for ball fields, equipment, and scholarships.

And now these players, along with their supportive family members and friends, are sharing their exciting stories and vintage photographs with the Latino Baseball History Project, local libraries, educational institutions, and the news media. Without many of these players and families, the Latino Baseball History Project might not have gotten off the ground in 2006. Some of these players are coauthors of this series, while others are consultants to exhibits and public activities, sharing their unique perspectives on how best to tell this fabulous history. In the last Field of Dreams chapter, the authors noted that many of these players are now playing on the big diamond in the sky. All of them are owed a debt that can never really be paid. The likes of these special players who brought immense joy and honor to their communities will never be seen again.

Victoria C. Norton (facing away from camera at bottom) signs books at the book release party of *Mexican American Baseball in the San Fernando Valley*, held at the Andres Pico Adobe in Mission Hills. Norton, along with Chris Docter and Richard Arroyo, served as coauthors for the book. Arroyo and Norton are former historical commissioners for the City of San Fernando. Docter holds a master's degree in history from California State University at Northridge. (Courtesy of Michael Crosby, San Fernando Valley Historical Society.)

Former Orange County softball players Edith Marval-Hallam (left) and Maria T. Solís-Martínez (right) are reunited at a book signing event held at the home of Jim and Gloria Segovia in December 2015. Both are highlighted in *Mexican American Baseball in the San Fernando Valley*. They are pictured with Monica Ortez (center), who coauthored a chapter on Orange County in the San Fernando book. Edith played for the Santa Ana Flames, and Maria played ball with the Air Force. At the event, Edith and Maria discovered they are related. (Courtesy of Richard A. Santillán.)

The Montebello Historical Society sponsored a Mexican American baseball event in September 2015. Wonderful stories were shared, photographs were displayed, and a book signing took place. From left to right are (first row) Rod Martínez, Mimi Poon, Bob Lagunas, Al Padilla, and Tom Pérez; (second row) Ray Ramírez, Ray Loya, Armando Pérez, Fidel Elizarrez, and Al and Frank De La Rosa. (Courtesy of Richard A. Santillán.)

This 1997 event was held at the home of Neno Félix in Pico Rivera, California, to honor legendary coach Dominck Campollo (center, white sweater). In no particular order are Conrad and Joe Muñatones, Art Velarde, Rubén Rodríguez, Donald Watson, Louie González, Gil Farias, Bobby Recendez, Henry Ronquillo, Armando Pérez, Gil Gamez, Fernando Farfán, Floyd Jeter, Ray Delgado, and Ralph ?. All of these men were outstanding baseball players from the youth to professional levels. Many of them later dedicated themselves to coaching. (Courtesy of Bobby Recendez.)

Pedro Seañez (center) is seen in 2015 with his two sons, Richard (left) and Greg (right). Pedro was an outstanding player for several teams in Juárez, Mexico, including Los Correos, Diablos Rojos, and Playa Azul. Richard and Greg were often batboys on those teams. Later, the family moved to Los Angeles, where Richard and Greg played on the same teams with their dad, including the East Los Angeles Arroyo Colorado. This team was part of the Mike Brito League. Arroyo Colorado is the name of the Juárez neighborhood where the family grew up. It was not unusual for Mexican teams in California to name themselves after their neighborhoods in Mexico. (Courtesy of Richard A. Santillán.)

On November 14, 2015, a book signing was held in Stockton, California. Several players and their families and friends attended the event. The Central Valley has a long and rich history of Mexican American baseball and softball in communities such as Stockton, Modesto, Tulare, Turlock, Planada, Tracy, Patterson, Riverbank, Lodi, Sacramento, Woodland, Merced, and Madera. From left to right are (first row) Randy Zaragoza, Roy Álvarez Jr., John Cardona, and Al Moreno; (second row) unidentified, Louie Valverde, Ben Valverde, Ray Cardova, and unidentified. (Courtesy of Richard A. Santillán.)

Pictured in 2008 are, from left to right, Santa Maria Indians manager Eddie Navarro; Robert López, age nine; and Robert's father and team coach, Ricky López. When Robert was 18 months old, his parents, Ricky and Gloria, were informed that he had a brain tumor. Growing up, Robert's life revolved around sports. From the ages of seven to nine, while playing for the Indians, he was the lead-off hitter, pitched, and played any position on the field. His leadership earned the team two league championships and one city championship. In high school, he played basketball and baseball. Meanwhile, he played with physical challenges and had several surgeries. Robert is now a certified umpire and will graduate from high school in 2016. (Courtesy of Gloria López.)

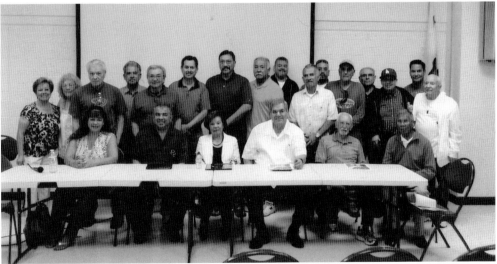

On November 7, 2015, a panel discussion, book signing, and baseball exhibit were held at the Claremont Public Library. The event was titled Mexican American Baseball in the Pomona Valley. Nearly 100 former players, family members, and friends attended the event. The Pomona Valley has produced outstanding players since the 1920s from Claremont, Pomona, La Verne, Chino, Upland, Ontario, Montclair, Corona, and Cucamonga. Some of these families now have four generations of players. This amazing group includes those who played youth, high school, college, community, women, military, and professional ball. (Courtesy of Richard A. Santillán.)

Longtime Van Nuys players Art López (center), and Ray Barraza (right), stand together at the book release of *Mexican American Baseball in the San Fernando Valley*, held at the Andres Pico Adobe in Mission Hills, California, on November 15, 2015. Nearly 300 former players and their families traveled to the event. Barraza, a San Fernando Valley sports legend, traveled all the way from Nevada City, California, while López came from Riverside. (Courtesy of Richard A. Santillán.)

When Ray Serra played ball on this field in the 1930s, it was known as Santa Monica Municipal Park, host to two games per night. Today, it is called Memorial Park. Pictured at home plate are Ray's three children, from left to right, Manuel, Alicia, and Ray Jr. Here they and the children of other former players spent countless hours of joy witnessing the history of Mexican American baseball in Santa Monica. (Courtesy of the Serra family.)

FIELD OF DREAMS

Mark A. Ocegueda (left), PhD candidate in history at the University of California, Irvine, and advisory board member for the Latino Baseball History Project in San Bernardino, and Steve Velásquez, curator of the National Museum of American History, display Roberto Clemente memorabilia from the Smithsonian collection, including Clemente's Pittsburgh Pirates jersey and helmet. Clemente's items were shown as part of the festivities for the Latinos and Baseball: In the Barrios and the Big Leagues event in Washington, DC, in 2015. Velásquez specializes in Latino history and collections and is from the Kansas City area. (Courtesy of Richard A. Santillán.)

East Los Angeles College head football coach Rick Gamboa (third from left) is presented the Los Angeles Dodgers Community Hero Award at home plate. Gamboa is seen with a Dodger assistant coach, his wife Gloria, and sons Richard Aaron (fourth from left), Michael Alan (left), and Matthew Brandon (little boy). The award recognizes a leader who has made an impact in the greater Los Angeles Latino community. College president Ernest Moreno resurrected the football program in 1998. Coach Gamboa led the Huskies in the inaugural ChiPs for Kids Bowl Game against El Camino College. This was the Huskies' first bowl appearance since 1974, when they won the California Community Football state championship under coach Al Padilla. Gamboa was a member of the 1974 championship team. (Courtesy of Rick Gamboa.)

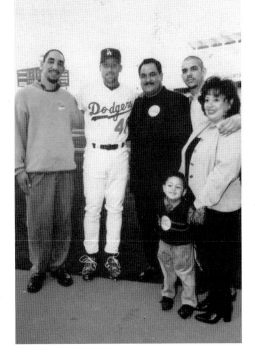

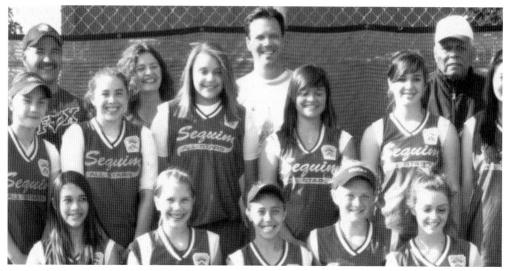

Coach Herman Murillo stands in the back row at far right with the 2009 Sequim Little League Girls All-Star team. His granddaughter Tia is in the first row, at center. After moving from Canoga Park, California, to Sequim, Washington, in the 1970s, he spearheaded the development of a baseball facility for the town. When Murillo passed away in 2014, over 300 family, friends, and former players attended a memorial held in the infield of Herman Murillo Field. The dugouts were festooned with the jerseys of teams Murillo had coached through the years. (Courtesy of Mary Murillo.)

Ray Loya Jr. was born in Los Angeles in 1938. He played youth, high school, and community baseball and professionally with the Dodgers and with teams in Mexico. He later became a pitching coach for several teams in Mexico and the United States, including the Cincinnati Reds. Over the years, he has coached major-league pitchers including Bobby Castillo, Joakim Soria, Mike Gallegos, Frank Pastore, Fernando Salas, Esteban Loriza, Richard Rincón, Rodrigo López, and Trevor Hoffman. Hall-of-famer Hoffman said that Loya had probably helped him the most to become a successful pitcher. (Courtesy of Ray Loya Jr.)

In early December 2015, a book signing was held at the home of Richard and Teresa Santillán in Alhambra, California. The event was a celebration of the release of two books, *Mexican American Baseball in the Alamo Region* and *Mexican American Baseball in the San Fernando Valley*. Several former high school baseball stars attended. From left to right are (first row) Paul Franco, Dave Vidaurazaga, Ray Lara, Jack Arenas, and José Romero; (second row) Rudy Martínez, Fred Martínez, Vic Morales, and Ray Loya. (Courtesy of Ray Lara.)

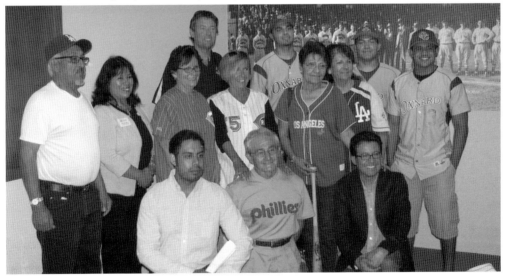

Curators Anna Bermúdez and José M. Alamillo pose with Lamberto M. García, who was a bracero in Ventura County. He, along with other braceros, formed baseball teams. Others in the photograph include the four daughters of Agnes Trejo, an outstanding player. Coaches and members of the Oxnard College team are pictured as well. The exhibit was entitled Béisbol: From the Barrios to the Big Leagues. From left to right are (first row) Juan José Canchola-Ventura, unidentified, and José M. Alamillo; (second row) Lamberto M. Garcia, Anna Bermúdez, and Trejo's daughters Rae, Gloria, Cathy, and Irene; third row, all unidentified. (Courtesy of the Museum of Ventura County.)

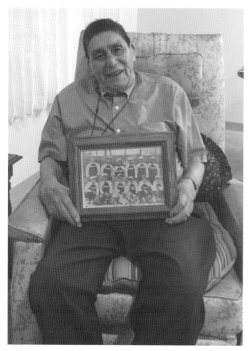

Hank Osuna displays a photograph of the Santa Paula Angels. Hank and his brothers Frank, Larry, and Ben played ball as young boys. Hank played for the Santa Paula Angels, and would travel to Los Angeles to watch Hollywood Stars games. He and two other brothers served during World War II. Robert was part of the Normandy invasion and was wounded, Freddy served in the Pacific with the Navy, and Hank, a medic, was wounded on Okinawa. He later played on a military baseball team in occupied Japan. Brothers Frank, Rudy, and Larry enlisted during peacetime. In 2009, Hank's amazing story as an Army medic was published by the *Ventura County Star*. A charismatic figure, Hank Osuna now enjoys watching games and sketching. He continues with a positive outlook and a sense of life well lived. (Courtesy of Juan José Canchola-Ventura.)

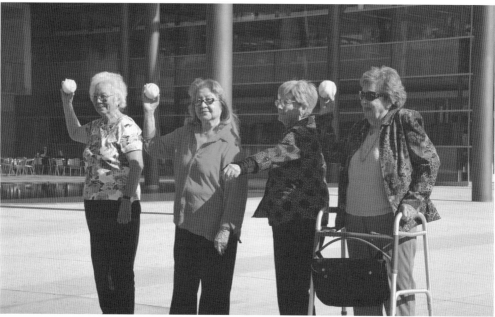

On March 25, 2015, the Chicana/o Studies Program at California State University, Channel Islands, honored several Mexican American women ballplayers with an exhibition, certificates, ball and book signings, and first-pitch ceremony. These incredible women were recognized for their athletic achievements and advancing gender equality in sports and making great strides in Chicana history. From left to right are Ernestina Navarro Hosaki, Mary Ramírez, Marge Villa Cryan, and Virginia Ruiz Durazo. (Courtesy of José M. Alamillo.)

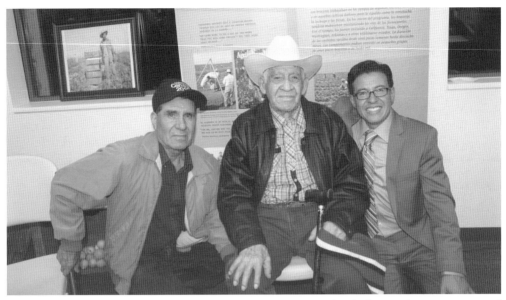

In 2008, California State University, Channel Islands, partnered with the Smithsonian's National Museum of American History to collect stories and photographs for an exhibition on the bracero program. Over 300 community members attended the exhibits, including 70 former braceros who were honored for their contributions to American history. This photograph shows Prof. José M. Alamillo with his father, José Alamillo, and grandfather J. Encarnación Alamillo, a former bracero. Professor Alamillo is currently researching the role that baseball played in the lives of the braceros. (Courtesy of José M. Alamillo.)

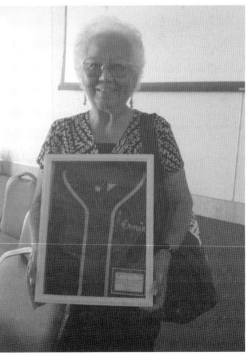

Ernestina Navarro Hosaki, a former pitcher with the Oxnard Merchanettes, stands with her uniform during a panel discussion at the exhibit Béisbol: From the Barrios to the Big Leagues, sponsored by the Museum of Ventura County. At 75, Ernestina earned three medals in a baseball competition with men her age. She continues to have the same energy and courage she did during her baseball days, encouraging her grandchildren to be athletes and embrace their Japanese and Mexican roots. (Courtesy of José M. Alamillo.)

LATINO BASEBALL
HISTORY PROJECT
ADVISORY BOARD

BIBLIOGRAPHY

Alamillo, José. *"We'd Rather Die of Hunger than Be Defeated:" Mexican American Struggle for Dignity in the 1941 Ventura County Citrus Strike.* Unpublished manuscript, 2006.

———. *Braceros of Ventura County.* Exhibition brochure, Fall 2010. California State University, Channel Islands.

———. "Peloteros in Paradise: Mexican American Baseball and Oppositional Politics in Southern California, 1930–1950." *Western Historical Quarterly* 34, issue 2 (Summer 2003).

Arreola, Daniel, D. Drew Lucio, and Christopher Lukinbeal. "Mexican Litchfield Park: A Forgotten Colonia of the Salt River Valley." *Journal of Arizona History* 49 (2008): 329–354.

Barajas, Frank. *Curious Unions: Mexican American Workers and Resistance in Oxnard, California, 1898–1961.* Lincoln, NE: University of Nebraska Press, 2012.

Cohen, Deborah. *Braceros: Migrant Citizens and Transnational Subjects in the Postwar United States and Mexico.* Chapel Hill, NC: University of North Carolina Press, 2010.

Galarza, Ernesto. *Merchants of Labor: The Mexican Bracero Story: An Account of the Managed Migration of Mexican Farm Workers in California, 1942–1960.* Charlotte, CA: McNally and Loftin, 1964.

García, Matt. "Ambassadors with Overalls: Mexican Guest Workers and the Future of Labor." *BOOM: A Journal of California* 1, no. 4 (Winter 2011): 31–44.

Harvest of Loneliness: The Bracero Program. Directed by Gilbert González, Vivian Price, and Adrian Salinas. New York, NY: Films Media Group, 2010.

Havens, Patricia. *Simi Valley: A Journey Through Time.* Simi Valley, CA: Simi Valley Historical Society and Museum, 1997.

Menchaca, Martha. *The Mexican Outsiders: A Community of Marginalization and Discrimination in California.* Austin, TX: University of Texas Press, 1995.

Órnelas, Michael R. *The Sons of Guadalupe: Voices of the Vietnam Generation and Their Journey Home.* San Francisco, CA: Aplomb Publications, 2000.

Santillán, Richard A., et al. *Mexican American Baseball in the Central Coast.* Charleston, SC: Arcadia Publishing, 2013.

Zamudio-Gurrola, Susan. *Housing Farm Workers: Assessing the Significance of the Bracero Labor Camps in Ventura County.* Master's thesis, University of Southern California, 2009.